Game Audio Mixing

Game Audio Mixing offers a holistic view of the mixing process for games, from philosophical and psychological considerations to the artistic considerations and technical processes behind acoustic rendering, interactive mixing, mastering, and much more. This book includes a comprehensive overview of many game audio mixing techniques, processes, and workflows, with advice from audio directors and sound supervisors.

Through a series of accessible insights and interviews, the reader is guided through cutting-edge tips and tricks to equip them to improve their own mixing practice. As well as covering how to plan and create a mix that is clear, focused, and highly interactive, this book provides information about typical mixing tools and techniques, such as dealing with bus structure, frequency spectrum, effects, dynamic, volume, 2D and 3D spaces, and automations. Key information about how to deal with a large number of sounds and their prioritization in the mix is also included, from high-level mixing visions to in-depth designs with sound categorizations at the core.

Game Audio Mixing is essential reading for all game audio professionals, including those new to the industry, as well as experienced professionals working on AAA and indie titles, in addition to aspiring professionals and hobbyists.

Alex Riviere is an audio director with more than 20 years of experience in audio. Alex has worn multiple hats in his career, including: sound supervisor, music supervisor, sound designer, music designer, voice designer, mixing engineer, music producer, and audio localization project manager. His work can be heard on many well known franchises, from console action-adventure open-world AAA games, to PC massive multi-player games, virtual reality games, as well as mobile titles.

"*Game Audio Mixing* is an absolutely critical and time sensitive exploration of one of the least understood and most complex elements of delivering high quality audio experiences for games. As we move to delivering larger and more complex audio experiences to our players, it's becoming even more important to approach the mixing process from the very outset of development. Alex has delivered an excellent how-to that is easy to digest and full of relevant examples from industry leaders across all genres. A must read, in my opinion."

Jeremie Voillot, Director of Sound Design, PlayStation Studios Sound

"This book is a great foundation for beginning and pro sound designers, music and dialogue designers and implementers. Alex's knowledge and passion on the topics at hand are unsurpassed. As a leader in the game industry he has extensive knowledge on how to balance a real-time audio scape, and what it takes to create a AAA worthy aural wonderland. We'll be adding this book to our arsenal of knowledge builders for our teams. Thank you Alex for taking the time to give your gift to the world."

Charles Deenen, Creative Director & Re-recording Mixer, SourceSound

"Alex has crafted a masterful look at the art and craft of mixing for interactive and emergent experiences. By combining his years of practice with insight and anecdotes from industry legends, he has created a narrative that is accessible, motivating, and inspiring for everyone. A fantastic read and highly recommended!"

Paul Lipson, Senior Vice President, Formosa Interactive Worldwide

"Alex's valuable industry experience and his techniques for both learning and self-reflection shared in this book make it a must-have for anyone interested in the craft of mixing. With emphasis on collaboration, it's an essential tool for audio professionals, game audio professionals, or aspiring audio engineers."

Glen Gathard, Creative Director, Molinare TV & Films Ltd

Game Audio Mixing

Insights to Improve Your Mixing Performance

Alex Riviere

Routledge
Taylor & Francis Group

LONDON AND NEW YORK

Designed cover image: Getty Images

First published 2024
by Routledge
4 Park Square, Milton Park, Abingdon, Oxon OX14 4RN

and by Routledge
605 Third Avenue, New York, NY 10158

Routledge is an imprint of the Taylor & Francis Group, an informa business

© 2024 Alex Riviere

The right of Alex Riviere to be identified as author of this work has been asserted in accordance with sections 77 and 78 of the Copyright, Designs and Patents Act 1988.

All rights reserved. No part of this book may be reprinted or reproduced or utilised in any form or by any electronic, mechanical, or other means, now known or hereafter invented, including photocopying and recording, or in any information storage or retrieval system, without permission in writing from the publishers.

Trademark notice: Product or corporate names may be trademarks or registered trademarks, and are used only for identification and explanation without intent to infringe.

British Library Cataloguing-in-Publication Data
A catalogue record for this book is available from the British Library

ISBN: 978-1-032-39738-2 (hbk)
ISBN: 978-1-032-39735-1 (pbk)
ISBN: 978-1-003-35114-6 (ebk)

DOI: 10.4324/9781003351146

Typeset in Goudy
by Taylor & Francis Books

Access the Support Material: www.routledge.com/9781032397351

Contents

List of figures x
List of tables xi
List of boxes xii
About the author xiii
Preface xiv
Acknowledgements xvi

Introduction 1

1 Mixing psychology 3

Envision mixing as a performance 3
Aim to reach a flow-state as quickly as possible 4
Mixing is all about making creative choices 6
Practice as much as you can and never stop learning 8
Don't live by your tools 9
Believe (in yourself) 9
Learn to know when to stop 10
Taking a step backward can be your best way forward 11
Keep a fresh perspective 12
Break the rules 14
Talking to: Gordon Durity, Executive Audio Director 16

2 Strategic planning 19

Find references and make an assessment 19
Build a mixing vision 20
Benchmark a few contents and mix them right away 21

Extract guidelines and rules from your benchmark mix 22
Define and design the tools you need to achieve your vision 23
The agile methodology is great to plan for macro mixing 24
Leverage 'L-states' to have greater visibility on your long-term planning, and to better define roles and responsibilities for the mix 28
The waterfall methodology can be better adapted to micro mixing 29
Set goals for any mix sessions 33
Put together a mixing taskforce 34
Get access to a large variety of playback devices 35

3 Game audio mixing basics 37

Mix at the right playback level 37
Consider your screen size 38
Listen to your mix at different positions in the room 38
Always mix and test in context 39
Make sure your contents sounds right at source 40
Work on your volumes first and foremost 41
When in doubt on a sound (or a category of sounds), lower your volume fader all the way down and bring it back up gradually 43
Use a hardware controller (or don't look at the volume fader value) when tweaking the mix 43
Mix things over time to keep your mix alive and interesting 44
Work closely with other disciplines to improve the mix 45
Talking to: Adele Cutting, Audio Director and Voice Director 46

4 Mix bus structure 51

Aim at a top-down approach first 51
The more modular the structure, the better 53
Categories and sub-categories of sounds can be mixed directly on the bus level 55
The bus structure can be used for sounds prioritization 56
Talking to: Rev. Dr. Bradley D Meyer, Audio Director 57

5 Sound prioritization 61

 If you don't need to hear something, don't play it! 61
 *Get your focal point(s) identified and sounding right first to
 build the rest of your mix around* 63
 Determine other priorities around the focal point(s) 64
 Critical sounds take priority over non-critical sounds 65
 Adopt the rule of 2.5 as much as possible 66
 *Snapshots are efficient to deliver a clear and interesting mix that
 feels alive, changing the focus for different gameplay or
 narrative instances* 70
 Cull on audio emitter levels to keep control over your mix 73
 *HDR is handy to reduce manual labor and for immediate results
 on busy gameplay instances* 76
 Use side-chaining to provide extra preciseness in your mix 77
 Use ducking only when it sounds natural 78
 Transitions are always key for a smooth experience 79

6 Frequency spectrum 81

 Corrections are on the contents level 81
 *Further spectral balance adjustment between sound categories
 might be necessary too* 82
 *Consider your game audio end-point(s) when working with
 frequencies* 83
 Subtractive equalizations sound more natural 84
 Beware of not changing the character of your sounds 85
 The energy and the sense of scale are in the lows 85
 The noisy range is around 2KHz 86
 The clarity, sharpness, and proximity feel are in the highs 87
 *Talking to: Tim Nielsen, Supervising Sound Editor, Sound
 Designer and Re-Recording Mixer* 88

7 Dynamic 92

 Favor leveling instead of compression to control volume 92
 Compression can be efficient to 'glue' things together 93
 *Parallel compression can be used to add impact and
 aggressiveness in your mix* 93

You can use (tonal) compression to make a sound or sound category feel 'bigger' 94
Multi-step compression usually sounds more natural 95
Talking to: Ben Minto, Company Director and Supervising Sound Designer 96

8 Acoustics 100

Define your acoustic strategy and goals 100
EQ your auxiliary busses pre- and post-effects 102
Don't hesitate to compress your effects 103
Calibrate your effects 103
Keep some sounds dry if it sounds better 104
Mix the reverbs a few dBs quieter than you originally thought 104
Talking to: Martin Stig Andersen, Composer and Game Audio Specialist 106

9 Space 110

Filter sounds in the extremities of the frequency spectrum to put sounds over distance 110
Balance your pre- and post-fader acoustic sends to set them backward in your mix 111
Early reflections at emitter position are great to keep focus in your mix while still providing depth 112
Use different acoustic treatments for high-SPL sounds over large distances to create a nice sense of depth in your mix 113
Apply pre-delay over distance for loud sounds with a strong visual cue 114
Use different positioning settings for different sound families to add further context in your mix 115
Leverage your speaker configuration and the technology at your disposal to further enhance readability 117

10 Mastering 121

Set time aside for mastering 121
If your game has different end-points, focus on one at a time 123

Stay true to your original intentions 124
A/B test your master (a lot) at the same volume as the unmastered mix 125
Get a second opinion 125
Test your master on as many listening environments as possible 126
Get your level and peaks under control first 126
Use compression to control the dynamic or to glue the mix pre-limiting 127
Use EQ to make your mix work best with any environment, or to tune the overall tone of your soundscape 128
Talking to: Loic Couthier, Supervising Sound Designer 130

11 Accessibility 134

Start with a design and plan early 134
Provide options for players to make their own version of the mix 135
A 'Focus Mix' version can be the base for many possible other accessibility mix versions 136
Most of the work happens on the bus level, and a little on the game mastering 137
A subtractive approach provides more natural sounding results 138
Get a second opinion 138
Talking to: Rob Krekel, Sound Supervisor and Audio Director 139

12 Last insight: There is no truth, only preferences 143

Index 145

Figures

1.1	Reaching a flow-state	5
1.2	Ideas to choices process	6
1.3	Mix progress expectations versus reality	12
2.1	Building a mix vision	20
2.2	Mixing with the agile and waterfall methodologies	33
4.1	High-level top-down mix bus structure	52
4.2	Mid-level modular bus structure	54
5.1	Focal point	64
5.2	Culling emitters versus culling voices	74
6.1	EQ cheat sheet	87
9.1	Light and sound speed	114
9.2	Sound families in the 3D space	117

Tables

2.1 LOQ Mix 30
10.1 High-Level Mastering Plan 122
10.2 Low-Level Mastering Plan 123

Boxes

Talking to: Gordon Durity, Executive Audio Director — 16
Talking to: Adele Cutting, Audio Director and Voice Director — 46
Talking to: Rev. Dr. Bradley D Meyer, Audio Director — 57
Talking to: Tim Nielsen, Supervising Sound Editor, Sound Designer and Re-Recording Mixer — 88
Talking to: Ben Minto, Company Director and Supervising Sound Designer — 96
Talking to: Martin Stig Andersen, Composer and Game Audio Specialist — 106
Talking to: Loic Couthier, Supervising Sound Designer — 130
Talking to: Rob Krekel, Sound Supervisor and Audio Director — 139

About the author

Alex Riviere
Photo by Emma Rose Falk

Alex Riviere is an audio director who has been working with sounds for more than 20 years. Alex has worked with game audio both in-house and externally, wearing multiples hats such as audio director, sound supervisor, music supervisor, sound designer, music editor, music designer, voice designer, as well as audio and localization producer. His work can be heard on many well known franchises and on a large spectrum of gaming platforms, from console action-adventure open-world AAA games, to PC massive multiplayer games, virtual reality games, as well as mobile titles.

Originally, Alex started his career as a composer and music producer for major music publishers. He then moved to the postproduction industry, working as sound supervisor, sound designer, and re-recording mixer on numerous commercials, trailers, and documentaries. Alex has then moved to the gaming industry, working as an audio director, combining his passion for games and audio.

Alex has unique international and diverse audio expertise, having worked professionally both in music, postproduction, and games, supervising and mentoring audio teams across the world. Alex likes to bring the best of both worlds by implementing techniques, ideas, and workflows from all these different industries and cultural heritages into his gaming mixes.

Preface

In games, crafting an outstanding mix starts during the content creation and audio system design processes. Mixing a game is a continuous collaborative task. But, during the live mixing phases, the person in charge of the mix has the opportunity and the responsibility to sculpt, transform, and embellish the overall sonic experience.

Over the past decade, working with different teams around the world has made me realize that mixing is a topic that a lot of game audio people are very keen to learn more about. One of the goals of this book is to help develop mixing awareness, one of the stepping stones which allow us, as game developers, to get dedicated people and the necessary resources and development time to deliver great game mixes. Because mixing in games is a team sport, perhaps we should look at it differently than in other industries (i.e., music, motion pictures, etc.). In games, it is often efficient to envision the person 'owning' the mix as a mix supervisor more than someone being hands-on in all the different mixing phases happening through the game development cycle.

This book has also been written with the aim of helping you reach the next level in your mixing practices. It can be used as a companion during your game development. The core idea during the writing process has been to share in the most efficient way the knowledge I have built by mixing interactive and linear medias over the past 20 years. The structure of the book is built around the simple goal of sharing insights, advice, and mix techniques in the most direct way for you to be able to find any specific information in a timely manner. Writing this book over the past two years has had me think a lot on the way I do things, continuously questioning myself on my methodologies and their outcomes. Why do I do things the way I do when planning? Why do I mix a game? How do I mix a game? Does it work for me? Does it work for others in my team? Does it sound good?

Even if there is more than one way to do things, if it works for me or for the teams I've been working with, then it might work for others, so it's probably worth sharing.

This book aims at providing a comprehensive overview of the mixing process for games: from the high-level physiological concepts of game mixing, to planning for your game mix efficiently, going through the pipelines, workflow, as well as sharing techniques to deal with frequency spectrum, building your bus structure, coping with dynamic, acoustic rendering, dealing with 3D space, mastering your game, and lastly, ensuring your game mix is accessible to all players.

This book is an invitation to join me in the mix stage; so let's get started and keep in mind that when mixing a game it's all the little things combined together that makes for a great, clear, and unique sounding mix!

Acknowledgements

All the people, game developers and audio-visual professionals alike, that I have had the opportunity to work with during my career.

My family, being by my side every day in life and providing me with joy, support, and happiness. My children, Milo and Asa, for taking their naps almost diligently. This is how this project started, taking notes on my smartphone lying down in bed alongside them.

I am also extremely grateful and thankful for the special guests invited to participate in this project. Adele Cutting, Gordon Durity, Loic Couthier, Rob Krekel, Brad Meyer, Ben Minto, Tim Nielsen, and Martin Stig Andersen. Thank you all so much for your contributions which go way beyond the content of the interviews and the quotes in this book. The discussions we had when preparing those interviews helped me to come up with better contents. Thank you for your time, your passion, your contribution to our game audio industry, and for your will to share your expertise with others. That is what this book is all about.

My current and previous employers and clients, giving me the opportunity to work alongside inspiring people every day, living my passion for games and audio, learning new things every day while still being able to pay my bills and support my loved ones.

Finally, thank you, you that are reading these words. This book has been written with the purpose of sharing knowledge and inspiring as many audio professionals as possible. Thank you for your support purchasing this book; I hope that it will help you reach the next level in your game audio mixing practice.

Introduction

Mixing a game, without the right processes or methods, can be quite tedious, with new goals and challenges always waiting around the corner. Unlike mixing for linear medias, games can be gigantic with very complex systems, making it almost impossible and extremely risky to wait until the last moment to start your mix. It takes months or years to mix a game, so keeping track of where you are with your mix at any moment and ensuring consistency for the player's experience can sometimes feel like 'mission impossible'. The difficulty then further increases as mixing in game audio is also very collaborative. A mix starts on the content level and finishes on the audio engine level. That process happens while the game is still under development, meaning that there are tons of game objects, audio emitters, sound effects, music, voices, and systems being created, added, developed, or iterated on all along the way.

Another noticeable difference between linear and games mixing is that in interactive medias you cannot always anticipate where the player is looking, where they are in the world, what they are doing, and how the game is responding to that. This creates interesting challenges to predict what sounds should be playing at any given moment, and where the focus should be. There are sometimes just too many possibilities. Ultimately, you always need to provide the listeners with clarity and readability in your mix to build the necessary engagement to understand the action, and to avoid any frustration leading the players to lose interest in the game. In games, and more importantly in the least linear ones (i.e., open world games, online competitive games, etc.), predictable mixing (anticipating the most common ways to experience the game) is key to build anticipations by using different mixing techniques to create contrasts (i.e., moment of silence before an important event in the game). Predictable mixing can also be about grabbing the player's attention with sounds, leading them to go and

look where you want them to, to improve navigation in the game environment (adding a sound and mixing it in a way that the players will inevitably look in a given direction) as well as highlighting subconsciously points of interest using sonic nuances.

Mixing a game is all about improving clarity and readability in the soundscape, but it is also about creating the necessary impact and contrasts to engage or re-engage the audience emotionally with changes in acoustics, pace, dynamic, frequency spectrum, etc. to further support or enhance the action, the narrative, or the sense of belonging to the virtual world.

Chapter 1

Mixing psychology

Envision mixing as a performance

With longer and longer game development cycles, game mixing can last for months or years. Mixing a game is like running a marathon, but it is one that is made of many sprints along the way. While mixing games is a very collaborative process (any sounds or systems being added or iterated on during the game development cycle can ultimately change the amplitude of a source, impacting the overall mix one way or another), one person needs to 'own' the mix to ensure a holistic consistent sounding player experience. It does not mean that person has to do all the hands-on mix work, but that they supervise and work collaboratively with the rest of the development team.

> 'Mixing is collaborative in an elemental way, but at the end of the day you cannot mix by consensus. Someone needs to own the final main mix and own the mix decisions'. (Gordon Durity)

If you have the right sources (i.e., the contents and systems that have been crafted prior to the mix), the right resources (i.e., the right number of people, the people skills, the necessary tech and tools, etc.), the knowledge, the artistic sensibility, an inspiring creative and audio direction, and the understanding of how your mix should serve such a vision, then one of the last variables that can affect the mix quality is your ability to perform. It is important to envision the mix as a performance, and to understand the fundamental idea of performance enhancement. In short, performance enhancement is about reaching a level of human excellence in your craft.

DOI: 10.4324/9781003351146-2

> 'Having a person holding or driving the vision is a necessity. Mixing is subjective, emotionally driven, down to taste and personal preferences. It cannot be a compromise of everyone's opinion, otherwise it will be flat and cold'.
> (Loic Couthier)

Performance enhancement in art is similar to performance enhancement in sport: an athlete and their training staff take into account several different factors to optimize their performance when preparing for a competition. Things like external factors, physical factors, training and skills, and strategies.

While training, learning, building the necessary skillsets, and defining the appropriate mixing strategy are essential to avoid having to work under unnecessary pressure, external factors (i.e., your social life inside and outside work, the game bugs occurring during a mix session, a milestone changing, a budget being cut, a mix time being cut, the weather, etc.) and personal factors (i.e., your mood, your stress level at work, your creative doubts, your ability to handle pressure, your sleep cycles, other physical factors, etc.) will also all impact the quality of your mix work. External factors in most cases impact your personal factors.

Understanding the concept of mixing as a performance and being aware of the different factors that could impact it are your first steps in ensuring consistent and quality work in your mixing craft in the long run.

Aim to reach a flow-state as quickly as possible

To make your mixing sessions more efficient and enjoyable you need to reach a flow-state as quickly as possible. This ultimately means that you are mixing in full immersion. When you are 'in the zone', your mix will come naturally and you will feel that you are performing skillfully and easily. This feeling of full involvement is extremely beneficial when mixing to perform with an optimum productivity, creativity, and focus.

There are different techniques to reach that state when mixing. The first is to make sure you focus on one thing at a time. Don't start mixing or reviewing features' pre-dubs without having a clear idea of how you want it to sound in the first place. It will help to avoid being distracted by any other elements of the soundscape you might want to fix on the fly. When you spot something that feels wrong outside of

your predefined daily topic (like an audio bug that might be bothering you), take notes, and come back to it later. An efficient method is to set goals for any mix session.

Another way to reach that mental state quickly is to set up a routine for your mixing work. Take the time to think about the upcoming mix session, think about the external and personal factors that could affect your day, and work on elevating your mood state. It is all about seeing past those factors during the mix session. Setting routines and daily goals for your mix practice is important to have a mental image of where you want to be at the end of a mix session. That way, you will be feeling in control and getting faster results in a relaxed way.

During the mix, try to avoid work distractions. Let people know that you are mixing, book yourself in your shared calendar if you have to, avoid getting into meetings or going through your work email. The information that flows your way from work might be distracting, and possibly generate frustration that will slow down your ability to focus on the mix.

> 'I tend to ignore all messaging systems during a mix. I let the team know I'm mixing so they know to look out for any urgent items I may need turning around, and then check to see missed emails and messages at lunch and mid-afternoon'. (Adele Cutting)

Finally, reaching a flow-state is also about the mastery of your game audio mixing skills. To reach that flow-state efficiently, it is important

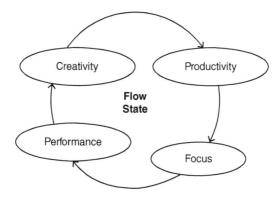

Figure 1.1 Reaching a flow-state

that the mixing tasks are not too hard, or too easy. You want to challenge yourself so that the mix of your game is right at the edge of your abilities, but not being so difficult that you become frustrated while mixing. This sometimes means that you have to manage your own expectations in regard to the end result.

Mixing is all about making creative choices

Mixing in games can often be seen as a technical discipline, but don't let your tools and systems drive your choices. Your skills, as well as the technology and tools at your disposal, should all be at the service of your artistic goals. Mixing is about making a series of artistic choices based on what you want to hear and how you want to hear it at any moment in a game. It could be for narrative, gameplay, world building, or other creative reasons. This often results in elements of the mix being removed, new elements being added, and audio systems being refactored or improved. Ultimately, the responsibility of the mixing person is to make choices among multiple possibilities and ideas offered by the team working on the game.

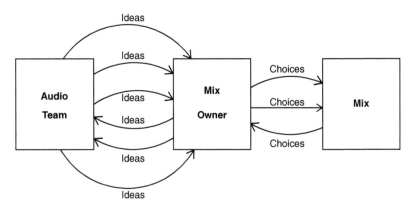

Figure 1.2 Ideas to choices process

The ultimate question that should drive your choices is 'why?' Why am I hearing this right now? Why is this sound category taking the lead in the mix? Why do I have both sound effects and music trying to convey the same message simultaneously? Why do I have sound effects playing detailed information here while the music or the voice is taking the lead in the mix at that moment? And so on.

'The mixing stage ideally is about creative decisions and not just problem solving'. (Tim Nielsen)

Those creative choices greatly depend on the game you're making. A good mix is ultimately serving the creative direction, the narrative direction, and game-design direction first and foremost. Mixing is, by essence, all about improving the listening experience. In games, this experience is very often tightly linked to clarity and readability (of the action, the gameplay, or the narrative). Try to have the game played in an expected way while mixing and trust your instinct. When in doubt, ask for feedback within and outside the audio team. As much as possible, try to leave any preconceived ideas and any possible frustrations aside (that could be generated from different forms of feedback). Making the right creative choices is subjective, but, for example, if you're working on the mix of a feature that is meant to improve the immersion through enhancement of the game realization, then besides the production value improvements that the mix should provide, if the mix of that feature speaks to you and others at an emotional level, that probably means you are on the right path. Alternatively, if you're working on the mix of a gameplay instance and your work has improved the readability, enhancing the understanding of the action from a player perspective, then you've probably made the right choices.

'Mixing is part of the creative process, not just a 'leveling' pass. That's part of it, but by doing it, it leads to further inspiration on how to frame moments'. (Adele Cutting)

All of this also comes with experience. Eventually your creative objectives should be driven by the idea to increase entertainment while playing the game. Keep your ambition, don't be afraid to try new things, learn from it, remain flexible, and follow your artistic instinct!

'When making bold mix choices you are exposing yourself to criticisms. I usually ask myself what hurts the least: getting negative feedback from people (which you need to welcome) or playing the final game without having made the effort to realize my best intentions for the game'. (Martin Stig Andersen)

Practice as much as you can and never stop learning

Even with the necessary knowledge in hand, one thing that only comes from experience is the training of your ears and gaining the perfect knowledge of your tools. Listening training is a good way to develop your ears. Listen carefully to other games and medias, analyzing the mix until you feel confident in knowing what you like and what you don't like about it. It all comes down to being able to evaluate what you would have done differently if you were in charge of the mix. Besides listening exercises, one of the most efficient ways to train your ear is to perform. Every time you have the opportunity, for professional or personal projects, practice your mixing. Any type of media is good (music, videogames, cutscenes, trailers, short movies, etc.) to develop your taste, your ears, and your skills. It's even better if you are able to try things in a low-pressure environment, investigating what works and what doesn't when making strong creative choices. It will eventually result in shaping your own mixing style.

> 'You will learn the most by practicing and by being present when the mix is going on, or with reviews of your mixes from a mixer you trust. If you cannot be given the responsibility of mixing the games you are working on yet, maybe you can try being the person playing the game for the mix supervisor, and practice with music or linear media mixing'. (Loic Couthier)

It can also be good to exercise your mixing practice within different aesthetic styles. Let's say you decided for training purposes to mix some trailers or cutscenes: take some with different audio-visual styles – realistic, intimate narrative, action-packed, futuristic sci-fi, animated cartoonish, etc.

Gaining experience through training and low-pressure projects will help you tremendously in your journey to develop your own mixing style. It would improve your capacity to adapt your skills and your taste to different types of media with different aesthetic visions. While you want to challenge yourself creatively during the mix, practicing will help build self-confidence, staying in control, and having fun during your performance. Those are essential skills and help to keep a flow-state most efficiently when mixing, as you feel on top of your game.

> 'Mixing is an ever-evolving process and one you should continue to learn from and experiment with throughout your career. You'll figure out some cool techniques that you take with you along the way. Never be afraid to experiment and try new things!' (Brad Meyer)

Training your ears and developing your mixing skills and style does not happen overnight. As audio professionals we are always learning new things, so you are ultimately embarking on a lifelong journey on this one.

Don't live by your tools

On top of ear training and practice, the main path to unlocking your creative possibilities is to master your tools. It can be a good habit to set aside time to test your tools thoroughly (digital audio workstations (DAWs), plugins, middleware, and game engine). Understand how these tools react to different types of sounds, what their limits and benefits are, and how you can use them on different mixing scenarios. At the end of the day, you do not have to use all the plugins at your disposal, or to use all their functionality, but you'll know your options and how to achieve your mixing goals in the most efficient way. After some time you'll reach a point where you know exactly what tools or techniques to use for a specific type of sound or for any desired mixing results. It's all about getting the best from your toolkit in a timely and efficient manner.

In games, it can also happen that you need to develop your own technology to perform your mix. Having the necessary expertise will help a lot to know your options. Working on different game engines, middleware, and for different gaming devices is great to evaluate more efficiently what are the options and what you'd want on top of those. It will help drafting paper designs for any new tools needed, so that other developers can better support you by developing the technology you need. As much as possible, try not to get stuck with the tools you have access to, but try instead to develop what you need to always have the technology at the service of the creative.

Believe (in yourself)

While you may be ready to make creative choices and have all the necessary skills and tools at your disposal, an important aspect of

performance enhancement that is also necessary to reach a flow-state is self-confidence. Self-confidence comes from practice, experience, having the necessary expertise, having the feeling of being in total control of your toolkit, and feeling on top of your practice.

> 'Situations that would have completely stressed me out at the beginning of my career would probably not today, because I've gone through that process so many times now. Practice is essential to be able to deal with possibly high-pressure situations when mixing'. (Adele Cutting)

Feeling in control of your creative choices can be an important aspect of this too, so sometimes you might want to be alone in the mix room. You might not want to have to think, explain, or make compromises when testing things. While mixing a game is a team sport, having time alone in the mix room can be beneficial to experiment, commit errors, and make creative choices. It feels good to have mix sessions where you can work by instinct and test things out, moving as fast as possible to get timely results on your creative attempts. Then, when you feel good about the results, ask others to join you for a listening session to gather thoughts, ideas, and feedback.

Trusting in your skills and choices is essential to achieve a great sounding mix and ultimately to gain the trust of the developers surrounding you.

Learn to know when to stop

When mixing, a common trap is to get obsessed or stuck over one thing for too long. When that happens it's usually better to just stop and move on. When you get stuck and start feeling obsessed by something it usually means you're over-doing it or trying to make something work that simply doesn't. It might also be a matter of perfectionism, which can sometimes be one of your worst enemies when mixing. Make sure to keep on schedule to avoid crunch or stressful times later on.

> 'If I really can't put my finger on the feeling that something isn't right, I'll walk away, or move on, and let it sit. I think somehow my mind will keep working on it in my subconscious'. (Tim Nielsen)

Another reason might be that you're getting tired or losing perspective on your mixing work. Taking a break or asking others often helps. If it doesn't, you should perhaps call it a day, or move on to something else. It's important to know when to stop, to not have too many regrets later on, often resulting in having to spend additional time fixing those things again later on.

> 'If I get stuck during the mix, or if something is just not working, after a certain point I move past it. I move onto the next bit and come back to it. Often, when I'm working on the next bit, suddenly the penny drops on a solution to the thing I was struggling with'. (Adele Cutting)

Taking a step backward can be your best way forward

Mixing a game happens over time, sequentially, with multiple listening sessions and mixing iterations along the way. It cans feel like an endless process, and you probably won't ever be fully satisfied with your mix. This is even truer for large games with long development periods where it is not uncommon to work on the mix organically for years in parallel with continuously crafting new contents and systems for the game. Mixing games sometimes feels like building a house of cards: if the base is not solid enough and your construction is not well designed and thought-out in advance, then as soon as you change something in the mix your balance could be at risk, and everything could collapse. When such things happen, or if your plans or goals have been changing along the way (because of a feature or the entire project pivoting creatively, narratively, or technically), then try to leave all frustration aside. Frustration greatly affects performance. Keep in mind that these changes can simply be part of the process. Work on accepting the fact that you cannot control all external factors impacting your work. Like with most creative disciplines, mixing a game does not have a linear progression toward a final result. There is always a chance that the creative or technical mix vision you had planned in preproduction becomes outdated at some point because of external factors (i.e., a change of release date, a new gaming platform available for your title, a new technology available, some new trends in the industry, etc.). Suddenly you have to change your mixing plans and possibly take a step (or multiple steps) back.

Mixing is by definition about getting things under control to move toward having a shippable game. But besides external factors, taking a

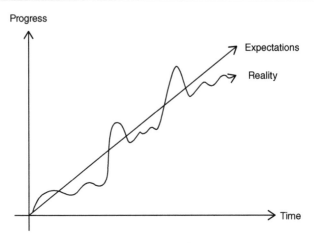

Figure 1.3 Mix progress expectations versus reality

step back (in making progress toward having a shippable game) could mean that you are making audacious creative choices, eventually resulting in having something more interesting sonically at the end. Don't be afraid to keep trying out new ideas. You will learn from it. Failing a mix day is ok – try to embrace it and learn from it; there might even be some good things to come out of it.

Keep a fresh perspective

The person in charge of the game mix has all the audio work in their hands and needs to make a neutral assessment of what needs to be heard. They are in charge of the holistic player-facing sonic experience, which is ultimately what game audio is all about. It is then essential to keep a fresh perspective without being too attached to the contents or systems crafted during the development of the game to make the right creative choices.

People creating and implementing content may have been working on the game for years. This often results in their finding themselves too emotionally attached to every single audio element of the soundscape.

The truth is that every sound doesn't need to be heard in the game at all times.

> 'When mixing, nothing is too precious. If a particular sound or mix shape is not serving the overall game aesthetic, then it's got to go. We

all fall in love with sounds or sound moments we've created, but if it's not working, save a copy for yourself for future use, pull it and move on'. (Gordon Durity)

Try to make sure you have enough resources so that the person mixing the game is not one who directly designed or implemented sounds. This is not always possible, but there are a handful of solutions and techniques you can use to clear your mind, depending on your situation and personality. For example, taking regular breaks is essential to keep your head straight and refresh your ears. Keep in mind performance enhancement and the physical factor explained previously: tired ears will lead to lower performance. Regular breaks will generally make your time more efficient once in the mix room. There are plenty of things you can do to clear your mind, such as getting some fresh air, going for a walk, grabbing a coffee or a tea (and taking the time to interact with someone at the coffee machine), etc. Whatever you feel works the best for you. One thing to avoid at all costs is work distractions. This can be tough in a game studio, but try to avoid going into meetings, doing backlog work, getting through your work emails, etc. Work distractions have a tendency to affect your ability to reach your flow-state quickly again when getting back to the mix room.

'It's important to take breaks for both your ears and your brain. Sometimes the best thing you can do for your mix is to put it down for a while, come back the next day, and listen to things fresh'. (Brad Meyer)

Another way to keep perspective on the mix work is to hear the soundscape through another person's ears. Taking breaks will help with that, as you will come back with a rested mind (and ears) in the mix room, but when in doubt, ask others to provide feedback. In game studios you usually have access both to other audio professionals and to non-audio developers. In many cases those people are gamers and could be representative of your target audience. You'd get very different types of feedback from audio and non-audio people. Audio folks have a tendency to provide more technical feedback, and non-audio people provide more experiential feedback. It can be good to work with both and address anything that you feel is relevant.

> 'Non-audio people often give emotional feedback. It can be beneficial to try to encourage them to express themselves in how it makes them feel, instead of stumbling with audio terminology. All feedback should be taken seriously, but not all should be actioned; that which resonates with your own hunch or that you hear from multiple sources is usually the most potent'. (Ben Minto)

Another technique is to go listen to your mix somewhere other than your usual mix space and setup. For example, if you're performing in a mix stage with speakers, take the build to your desk and play the game with headphones. Sometimes the change of environment, listening devices, even the screen(s) you're playing the game on, can help tremendously to spot any imperfections in your mix. Similarly, asking for someone else to play the game and for you not to be right in front of your computer can help too. Moving away from your hands-on mixing station to a listening and evaluating station (i.e., standing up or sitting on a sofa in the back of the room) can potentially make things more obvious.

Finally, having objectivity on the mix work can feel difficult when working to tight deadlines, increasing the stress level during your mix days. Whatever the difficult reality your game production might be facing, always try to keep in mind that making games should be fun. Crafting and mixing sounds that fundamentally provide entertainment, engagement, and allow for people all over the world to escape from their everyday life is an amazing feeling that should help put a smile on your face and put things into perspective.

Break the rules

Game audio mixing is a relatively recent craft with technology and mixing methods moving fast, but engineers have been mixing music and movies for decades. Making mistakes, embracing failures, and thinking outside of the box are the things that have given us the common mixing rules and guidelines we have nowadays. There are indeed some basic rules when it comes to mixing (i.e., technical rules like 'don't clip', mastering loudness targets, etc.) as well as a few limitations or constraints (due to the technology you are using to develop your game: engine, tech budget, etc.), but as soon as you understand the common rules and master your tools by having practiced mixing for a while, you should then feel ready to try new things.

'The more solid a mix, the easier it becomes to deviate from the norm. This has probably to do with the fact that we're accustomed to hearing, and to some extent accepting, bugs when playing games. So if my base mix is vague, bold moves will potentially be heard as bugs'. (Martin Stig Andersen)

Feel free to take initiatives and creative risks. The important point here is to keep in mind that the best way to be creative with your mix and achieve something special is to throw away any preconceived ideas. Allow yourself the time to try new things, even if it ends up being thrown away for this project. You might also end up with something so special that your mix could result in being seen as an inspiration for other people, helping to shape and define new modern mixing trends for games.

Talking to: Gordon Durity, Executive Audio Director

Gordon Durity is an audio director currently working as Executive Audio Director at Electronic Arts. Gordon heads up a global team of creative and technical audio artists supporting a large part of EA's game portfolio. He also runs R&D into future-looking technologies and player trends and desires, and consults on a variety of internal tech systems.

When starting a new game project, how do you like to plan your mixing?
From early preproduction it's important to get a sense of the scope and ambition of the game. Even though this can and will change, sometimes dramatically, it gives a starting place to think about mix hierarchy and structure. I'm always thinking about what is most important to communicate in the game at any given moment and what's important for the player to focus on.

An initial audio target and vision is essential before any in-the-trenches work begins. This audio target is a living asset as it will evolve and be broken up into smaller more specific pieces. The audio target is your creative razor! At any time throughout production you can refer to it to check how or how far you may have strayed from it. At the final mix, I like to pull up the audio target video against the playing game build and see how it measures up. Hopefully, the game is as good or better than the audio target video.

It is also important to review other games and movies that may stimulate your creative juices. On the other hand, an anti-vision (or what bad sounds like) is also useful in pointing out what not to do. Listen critically! It is important when reviewing reference material to what is working and why, as well as what's not working and why.

In dealing with 'agile' versus 'waterfall' methodologies, both have their benefits and uses. There should be clear goals and expectations for any key milestones and/or the end of key sprints. But the creation and tech work being executed between sprints and milestones should be able to be done in an open and flexible enough way that exploration of solutions can occur.

When the question of when to mix arises, I generally say as soon as possible. Keeping the game in a constantly 'mixed' state helps gives perspective on where things are at any given moment. This will encourage good audio production processes for things like audio asset levels, frequency clashing, clarity, and allowing you to get reasonable feedback. I can't remember how many times I heard audio leads say 'that's not how the game really sounds' after a build review. If I sync a build that the rest of the development team is playing, then at that moment in time, that is exactly how the game sounds. Some good advice I received from an executive producer a long time ago was, if the game had to final and ship in a couple of weeks from now, how would it sound, regardless of the state it's in? Book time into your schedule to mix the game constantly, so you won't be caught in a mad scramble at the end. No matter how amazing the implementation is or how fantastic the sound design and speech may be, a bad mix can kill it. Conversely, a great mix can make a more simplistic audio approach, with less than stellar audio content, sound good to the player.

Mixing is often a collaborative process in games: put it this way, mixing is also part of the implementation of any audio contents, as anything that varies in amplitude based on variables affects the overall balance. Do you prefer one person to own the responsibilities of the mix or do you believe in shared ownership?

Mixing is collaborative in an elemental way, but at the end of the day you cannot mix by consensus. Someone needs to own the final main mix and own the mix decisions. It is important early on to establish audio asset creation loudness levels and frequency band zones based on category of sound type (e.g., explosions, body Foley and feet, near and far ambience, walla, etc.). This will give the other audio artists on the game a clearer direction on how they should monitor and build the audio assets they are creating. I've found that by this simple process of getting content levels and timbres right before importing into the engine, the game can practically start mixing itself. The less I have to do to correct poorly conceived audio assets by corrective equalizations (EQs) and level adjustments, the more creative freedom I have on the mix and the clearer and more detailed the mix can be.

Game mixing often has two main aspects to it: content mixing and live mixing. How do you like to approach both aspects of the mix?

For content mixing it is very useful to have the content created at established volume levels and frequency zones for audio asset categories. For example, big impact effects, background airs/tones, main dialog, loud emitters versus soft emitters, etc., should all adhere to general asset creation guidelines. When the raw assets are imported in the game engine, their relative levels, already established, should allow the game audio to start almost mixing itself once implemented.

Beyond that I like to keep as much dynamic as possible via the real-time and snapshot mix setups in the game engine audio system.

On top of any specific mixing goals you may have for a title, mixing in games is usually about improving the clarity of information provided to the players at any moment in time. It can be a challenge when hundreds of voices could possibly play at the same time. What are your main techniques and considerations to improve readability in a game mix?

This is a big question, lots here. Clarity and focus are the goals above anything else. A mix can be a daunting thing. I like to break things down into smaller chunks and start from a simple first approach. For instance, there may be dialog, music, foreground battle sound effects (SFX), car engines, animals, crazy fantasy environments, heads up display (HUD)/user interface (UI) SFX, etc. That's a lot going on. I will work on paper, whiteboard, flow chart, whatever works for you, creating a hierarchical relation diagram from the most important categories of sounds to the least important that communicate the essence of the game and provide the desired experience for the player.

I will also use my 75–85% rule, which is to identify what the player will be listening to 75–85% of the time while playing the game. Is it gunfire, is it player Foley,

is it hockey skates and sticks, is it car engines? How you treat these often-heard elements has a major impact on the success of your mix.

Similar to film mixing, the most important thing is to support what the game is communicating at any given moment. I subscribe to the Walter Murch idea of being able to focus on roughly 2.5 sounds at any one time. To this end we use all of the mix tools and techniques available to us. Having good clean and defined audio content to start with helps a lot. So any de-noising or equalizations that can be done ahead of time on the asset level will help. I use the real-time digital signal processor (DSP; like EQ, compression, filtering, etc.) for creative mixing versus corrective mixing as much as possible. A simple mix conception is cut versus boost, and cull versus add. So, to make something more noticeable, or to bring it into focus, try cutting things around it that may be clashing. You can also try a simple method where once your core steady mix is established, for anything new thing you add, you must pull something as well. Think of it as a bowl of fruit that is optimally full. To add another item, you must first pull an item in order to keep that perfect balance otherwise you run the risk of adding too much to the bowl and having some or all the fruit spill onto the table.

When mixing, remember that nothing is too precious. If a particular sound or mix shape is not serving the overall game aesthetic, then it's got to go. We all fall in love with sounds or sound moments we've created, but if it's not working, save a copy for yourself for future use, pull it and move on.

When working with surround, do you keep the center channel exclusively for narrative dialogues, or do you like to make more creative use of it?
The only place where I like to keep the center channel for prominent use is for a sports announcer. Even then, I like to leak ambience and panning across the center as well. This prevents a hole in the middle of your mix. For something like a car engine, you need to have some up the middle to anchor the car for the player, but I will definitely use ducking and panning effects to dynamically alter the level of what is going into the center. Even for surround ambiences, while quad is still used a lot, I find that a 5.0 ambience presentation with very little signal going to the center statically and dynamically can yield a more full and satisfying experience.

From your perspective, what does the mastering of a game consist of? What's your process on that topic?
For me mastering a game is really about controlling the mix's overall level before hitting the digital to analog convertor (DAC). I tend to keep it simple, get the integrated level at around -24LU (+/- 2LU) and true peak at -2LU. Fancy creative mix adjustments are done upstream on a sub-mix or channel level.

On my master bus I use a limiter fed by a compressor. The limiter catches any potential stray peaks, and the compressor contains the mix as a whole. I want to use this as lightly as possible just to hold things together and not any weird coloration or pumping. Any creative DSP effects are done upstream in the mix.

Chapter 2

Strategic planning

Find references and make an assessment

Before starting to get hands-on with your mix, make sure to take the necessary time for a research and analysis phase. This could include looking at other games, movies, videos, etc. that have a shared aesthetic vision with your project. Find reference materials that you think would speak to your target audience at an emotional level. The idea is to define your strategic position by setting the bar high, taking the best mixes within a similar genre available on the market, and making an assessment of how they did their work. This list of projects would need to be revisited from time to time during your game development cycle to keep things up to date. Making games takes years, and industry trends and technologies are evolving quickly.

> 'It is important to review other games and movies that may stimulate your creative juices. On the other hand, an anti-vision of what bad sounds like is also useful in pointing out what not to do. Listen critically!' (Gordon Durity)

While analyzing other games, play them thoroughly, capture videos, take notes, and write your thoughts. What did you like about the mix, what did you not like? Try to run some spectrum and loudness analyzers, read articles, watch behind the scenes, and very importantly: document it all. This documentation is the first step toward building a mix vision, and it will be very handy to compare your work against those references.

> 'There should be preproduction work completed that defines what the high-level goals are for the mix, with plenty of reference; maybe from previous

titles, other games and even other media (film, TV, YouTube etc.), as well as suitable anti-visions'. (Ben Minto)

Build a mixing vision

After the analysis phase, the logical next step is to define a vision for your mix. This is a key step in developing a strategic plan. The mixing vision, on top of the documentation and references mentioned previously, can be made of a few high-level pillars answering a simple question that could lead to a complex answer: 'Why are you mixing your game'? Do you only want to increase the production value of your title? Are you also aiming to improve readability? Add clarity? Improve narration? Provide a cinematic feel to your game? Enhance gameplay to create a better sense of strategic and tactical immersion? Add impact and contrast to your game? Improve the CPU usage of your game? The reasons can be varied and differ from one title to another. Being able to answer the 'why' will help you tremendously in defining your mixing pillars. Defining high-level concepts of what you are trying to achieve with your mix will help you and the rest of the development team down the line.

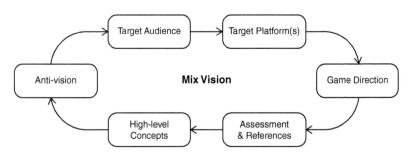

Figure 2.1 Building a mix vision

As your mix vision should ultimately serve the creative, the narrative, and the game direction of your game, it is good practice to build it in a way that it could speak to other game disciplines. The more people embracing your vision, the more support you and the rest of the audio team will get for collaborative cross-discipline work, which is essential in delivering a good mix. Mixing a game goes way beyond dealing with audio signals and crafting audio aesthetic choices. Making choices should often be about improving the gameplay and

narrative experience. For audio to support gameplay, you need other design teams, art, and animation and visual effects (VFX) teams to collaborate closely with audio. For audio to support narration, you need the narrative team, the writers, the narrative designers, the art, animation, and VFX teams to have the necessary awareness of what you are trying to achieve.

> 'I like to start a title with a high-level idea of how I want it to be mixed, and which techniques I may use'. (Loic Couthier)

Benchmark a few contents and mix them right away

After the assessment and high-level visionary phases, it is time to get started with some actual audio work. The goal is to translate your vision into something tangible, like a style guide. Starting the mix early on allows benchmarking and mixing sounds for a few features to demonstrate your aesthetic approach, which is extremely beneficial for you and others. It is all about evaluating your mix vision on a controlled scope, taking the time in preproduction to test different ways to achieve your goals, and to develop further ideas based on your preliminary assumptions in a 'non-stressful' controlled environment.

> 'An initial audio target is essential before any in-the-trenches work begins. This is a living asset that will evolve and be broken up into smaller more specific pieces. It is your creative razor! At any time throughout production you can refer to it to check how or how far you may have strayed from it'. (Gordon Durity)

Getting a few contents at ship-able quality in preproduction will help deliver your best mixing performance, because of the focused aspect of this exercise. You would be working on setting a high-quality bar for the game mix. This step in your strategic plan is make or break as, based on a tangible test with limited scope, you could perhaps decide to come back to your mix vision with new ideas, or to move on with your original plans. It will also help you start to define the tools and additional resources you may need to deliver the final mix in the long run. This benchmark will be used as a guide for you

and the rest of the audio team to calibrate your ears when designing and adding contents in the game later on. It is also something you will be able to come back to, to make sure you stay on the right path along the way.

When deciding what type of sounds to benchmark, think about what are the most important types of sounds for your game. Do you have any audio signature features? What sounds are essential to deliver your vision? Do you have any aesthetic or technical risks, or uncertainties that you would like to flesh out early on?

Being early in the preproduction phase, this step is about conceptualizing audio outside of the game engine environment. The format used is often to make a few target 'previs' (pre-visualizations). 'Previs' are linear video captures of your game (or sections of your game) with audio contents created and mixed in your digital audio workstation. These style guides are made in a 'controlled environment' to deliver a more precise vision for your mix. In the eventuality that the game does not have enough visual contents implemented yet to make good video captures and edits, then any good moving or static inspiring visuals you have at your disposal can work. It's all about getting started with the creative process and translating ideas into concrete audio demos. For example, if you want to showcase the mix and contents for an environment feature, you could craft a 'sonic postcard', which is a few minutes long sonic representation of your environmental soundscape playing on top of a selection of concept art. Once the game has more visual contents later on that are representative of its aesthetic art and creative vision, you will be able to revisit those 'previs' or make entirely new ones. Once your game has a decently realized functional build, you could start exporting the contents from those 'previs' mixes, and try to reach your mix targets in-game.

Extract guidelines and rules from your benchmark mix

As your benchmark mix should be a representation of the final quality level you're aiming for, the contents and the way they are mixed can be used to prepare for larger chunks of the game to be produced later on. Extracting implementation guidelines and contents mastering rules from your benchmark mix in the form of a spreadsheet is an important aspect of collaborative mixing work. It can also be convenient for a one-person audio department. It's all about drafting a plan of action to keep the mix under control at any given moment in time.

> 'During preproduction a linear asset should be produced that demonstrates the mix qualities wished for in the final product – a target that sets the reference in terms of loudness, frequency content, transients, and compression, amongst other variables, that then guides the creation of further assets and mix strategies'. (Ben Minto)

Every sound category (i.e., 'player Foley', 'player weapons', 'player gears', 'explosions', 'player voice and exertion', 'non-playable character (NPC) voices', 'NPC weapons', 'ambiances', etc.) should be referenced with information such as targeted playback volume (in RMS or LU depending on your preference), frequency spectrum, dynamic range, auxiliary sends volume targets, as well as any other mix details you think might be useful for your project. If somehow you don't have all this information to hand yet, try to extrapolate from the contents you already have, and keep updating your documentation along the way. It is very common that your plan will change over the course of game development, whatever your level of seniority, the size of your team, or the complexity of the game you're working on.

Independent of how many instructions you may want to add to your spreadsheets, the key is eventually to share the most relevant information for any audio person working on contents and their implementation. These guidelines will help anybody making sounds on your game to calibrate the mastering of their assets at the right-targeted loudness at source within the right frequency spectrum, reducing the amount of mix tuning needed in the game engine during the implementation phase.

> 'I like to set "mixing standards" for collaborative work. It is about establishing, as early as preproduction, all the mix requirements for the audio contents and implementation (DAW, audio engine, in-game mix). We review this "mix-compliance" for every piece of content, as they are added to the game'. (Loic Couthier)

Define and design the tools you need to achieve your vision

An essential step in strategic planning is to define the resources needed to achieve a vision. Depending on the tech you have access to

(engine, middleware), you may have to get additional dedicated mixing tools to perform your mix fully (i.e., culling systems; reflection systems; sound propagation systems; etc.). The preproduction phase of a game is a good time to start defining the tools you need, and to get started with high-level paper designs.

> 'Make sure you have an idea of the audio systems that you'd like to employ game-wide for your mix. Think about this right at the start of the game development, as they can be difficult to shoe-horn in half way through, without causing multiple knock-ons'. (Adele Cutting)

The core idea here is to focus on the 'what'? For example, what are your primary needs? What challenges are you facing? What technology will help you deliver on an experiential or technical level (i.e., CPU optimizations)? Perhaps if you need assistance from code to develop proprietary tools, you may have to explain the 'why' as well to others (i.e., producers and coders). It is always good to be prepared for that discussion to happen too. Why is the available technology not allowing you to deliver the mix? Why do you need access to those tools? The heavier the tools needed, the more you will have to plead your case. Try to keep your design as clear and high-level as possible. It's good to evaluate your options, but don't try to answer the 'how' (except perhaps if you are an audio programmer yourself, or someone with a strong technical development background). In most cases, it is better to leave that to other people with a different expertise as they might offer better (and faster, or cheaper) ways for you to get the tools you need.

Once the tools are defined and the resources allocated, plan so that you can collaborate with your allocated tech partner in a sequential way. Be agile, implement and test things step by step; don't worry about stopping or taking a step back when your original plans don't provide the expected results, and make others aware that more tools might be needed along the way.

The agile methodology is great to plan for macro mixing

Mixing in other type of mediums (i.e., music, movies, trailers, etc.) generally happens toward the end of the production process. Things are different when it comes to games. Mixing in games starts as soon as you have more than two sounds playing in a build, and can often

be broken down into two high-level concepts: the macro mixing and the micro mixing. There are two main aspects of macro mixing: the first is about pre-mixing (and mastering) audio contents at source. If you are working within an audio team, this is usually considered a team responsibility. Pre-mixing contents at source is all about equalizing, de-noising, controlling the dynamic, layering, printing, and implementing contents with both interactivity and mixing flexibility in mind. This step is key to ensure every single audio element created for the game is ready for live mixing in the holistic and dynamic aspect of the game. Another aspect of macro mixing is about pre-mixing on a feature level. It can sometimes feel unnatural to call those 'mixing passes' because the work tends to feel more like pre-mixing as you usually cannot commit to anything being 'final'. The core idea is to keep the game in a stable and maintained audio state at all times. Macro mixing can then feel quite similar to pre-dubbing in post-production, except that you'll be working on those pre-dubs in a continuous, iterative, and very collaborative way. Micro mixing in the other hand is all about dedicating time exclusively for mixing (and mastering), targeting very specific goals, diving into more detailed work. Macro mixing is often when most of the technical mixing work happens, while micro mixing is where you would want to focus almost exclusively on artistic choices and polishing work.

> 'Mixing is a continuous process. The start of the mix is putting that very first sound in the engine and setting its volume, its attenuation, etc. The next step is adding a second sound and mixing that relative to the first one and so on. It's an additive process'. (Brad Meyer)

When it comes to planning, the mix should ultimately be considered like any other audio discipline. Similarly to sound design, voice design, audio code, or music design, plan your mix with your production partner to avoid this important step in the game audio production pipeline being unplanned, hidden, unseen, or considered as a 'nice to have' from a production standpoint. A good way to allocate time and resources for it in your production plan is to build a mix backlog. Embrace the agile methodology commonly used in games. Agile is a project management method that relies on cross-disciplinary collaboration as well as step-by-step development. Each iteration is made up of 'sprints', lasting two to four weeks depending on your studio and the size of your project, with multiple objectives

per sprint (usually named 'user stories'). Those stories, classically written in the form of 'As a player, I want to experience...', or 'As a player, I want to be able to...' allow the team to develop important features, leading to having a deliverable testable build at the end of each sprint. As macro mixing is a lot about mixing 'on the go', using the agile methodology should feel painless. It is also a good way to provide awareness across multi-disciplinary development teams. You can then talk about the mix during stand-ups, plan for it during planning days, etc., resulting in improved audio and mixing awareness across the board. It is good practice that anything concerning macro mixing should be logged in the backlog, even if you feel some of it should be part of your content creation or implementation tasks. Beyond pre-mixing on the contents level, time-boxing a day or two per sprint (or any other sprint) during planning can be a good way for the person in charge of the mix to review, test, listen, or start hands-on work on features or stories. The backlog is also where you want your tools dependencies to be, so that you can work with programmers in a sequential way. When it comes to building a macro mixing backlog, there are different possible strategies. One consists in adding a mixing task for any audio-specific user stories, or any 'epics' or features; and another is to create a completely separated mixing backlog. The right process depends on your game, the size of the team, your personal preference, and the preference of your production partner (or the backlog 'owner'). The overall method when building a mix backlog is to break down your tasks, estimate the complexity and the time you think you'll need to achieve your goals, and prioritize them. The amount of time you may want to allocate for your macro mixing on a per-sprint basis depends on how large your audio team is, how large your features are, how long your sprints are, what are the dependencies that might be blocking your work, and how many audio contents and systems are implemented every sprint.

> 'Mixing is ever-present day to day: content designed and implemented to standards, in-game pre-mix reviewed for every feature. It is scheduled as part of the development process of each task. Every single task includes mix sub-tasks!' (Loic Couthier)

It's often a lot of back and forth and a very collaborative effort to mix on the go. Making sure you always have a solid balance in your

build and keeping things organized are important to give the right impression to other developers. You are then more likely to avoid unnecessary feedback or bug reports like 'the footsteps sounds strange' or 'we cannot hear NPC voices', etc. People are more likely to complain or add a bug ticket when something is too loud, too harsh, or is masking another element of the mix than about something too quiet or missing entirely (often considered a result of being a 'work in progress').

> 'Keeping the game in a constantly 'mixed' state helps to give perspective on where things are at any given moment. This will encourage good audio production processes for things like audio asset levels, frequency clashing, clarity, and allowing you to get reasonable feedback'. (Gordon Durity)

The iterative aspect of the agile methodology is also beneficial because it allows the person supervising the mix, and the rest of the audio team, to take a step back when necessary and re-adjust things along the way. Another benefit of maintaining your macro mixing on the go is that it allows the mixing supervisor to review in-depth the work from the rest of the team from a mix standpoint. This is extremely useful to ensure you have all the necessary granularity with both the contents and the systems to reach your final mixing goals. It's about making sure you have all the prepared ingredients you need to cook a very tasty dish, and to be able to present it in the most elegant way possible. It will also help the audio team to craft 'better' mix-oriented contents and systems along the way. People will then be working more and more on things that will feel right at source by getting a better understanding of how things should sound when the game is done.

Finally, as you are getting things in control along the way, pre-mixing in an agile manner is also obviously a great way to de-risk your other more 'traditional' mixing phases. With this approach, the more you progress within your game development cycle, the more will have been mixed. This results in working under less pressure at the end of each cycle. You never know what might happen during the development of a game, and the few weeks that were promised by production before generating a build candidate for a milestone might disappear for multiple unforeseen reasons.

Leverage 'L-states' to have greater visibility on your long-term planning, and to better define roles and responsibilities for the mix

Setting objectives and prioritizing them is a crucial part of your strategic plan. It should allow you to lay down your goals and their corresponding tasks in order of priority. This results in populating the backlog and an audio mixing production roadmap. It will help tremendously to evaluate if you have the necessary resources to achieve your goals, and to keep track of where you are in comparison with your preliminary objectives during the whole game development cycle. That being said, games and their corresponding backlog can be so large that it can feel cumbersome to create a mixing roadmap early on. A good method for this situation is to use the 'Level of Quality' (or 'L-states'). This method is often used by production to evaluate the completion of different epics or features. L-states are made to measure the progress and quality of the different features of a game project within the agile methodology. Those levels of quality are broken down into different stages of backlog completion, such as 'L0' (paper design, concept, creative brief), 'L1' (prototype), 'L2' (fully functional), 'L3' (shippable), and 'L4' (shippable with high-quality target). The definition of 'done' within those L-states can differ slightly from one studio to another, or from one project to another within the same studio. Depending on your production reality, it can happen that not all features of your game will reach 'L4'. Production can decide that most features won't go beyond 'L3', except a handful that would need to reach 'L4'.

Leveraging the L-states process to define the definition of 'done' for your mix can be great to have a wider visibility on the delivery of your features and their corresponding mix. Things can then be translated more easily into a high-level mix roadmap for any features or epics in your backlog. It is the responsibility of the mix person, the audio team, and production to agree on the definition of done per L-state for the mix, alongside the roles and responsibilities to be shared between the audio team members and the mix owner for every state. For example, 'L0' is the concept phase, so it is ideal to create the creative brief for the mix of your different features, as well as working on your 'previs' targets. As this stage is more about visionary work, the mix owner should be very involved. 'L1' is about building and testing functionalities. Being mostly a prototyping phase, the role of the mix owner should be very limited. It's the role of the audio team members to 'mix on the go' to keep the soundscape in control. As

you progress toward 'L2', 'L3', and 'L4', the role of the mix owner becomes more prominent, making more and more creative choices to make sure the most important elements of the soundscape are delivered in the most elegant and efficient way sonically as part of the holistic experience. The responsibility for the team is then usually to follow the mix and implementation guidelines (loudness, frequency spectrum, dynamic, panning rules) originally created in 'L0' (and often iterated on in 'L2' and 'L3' by the mix owner).

The waterfall methodology can be better adapted to micro mixing

The concept of micro mixing is similar to the traditional mixing phases that exist in other industries. You may then ask yourself the question: if we keep the mix maintained along the way, why would we need to plan for more mix passes? Mixing on the go does not mean you don't need a mixing pass before any important milestones. Similarly, doing a mixing pass at the end of the process also does not mean you don't need to work efficiently on your pre-mix. The goals and focus are different. While mixing regularly allows you to keep things under control with generally a focus on anything systemic, micro mixing will allow to take a step back, make any necessary adjustments, work on your mix details, address any notes and feedback, and focus on the player experience within what is usually referred to as your 'golden path'. Micro mixing is when you would generally break the rules, including your own, to create more contrasts in your mix. You would then have time dedicated to crafting a mix experience that provides a stronger emotional response. Micro mixing is often the stage where you would make your strongest artistic choices to better impact the listening experience.

Another type of project management methodology is often more appropriate for these micro mixing phases. The 'waterfall' methodology is better adapted to allocate a few days or weeks before any important milestones to 'live mix' the game. While agile scrum is the project management method that is commonly adopted in games for iterative and collaborative work, as soon as you 'know' what you are building, how to build it, and that you need to set time aside for it, the waterfall methodology works better because of its linear, schedule-based, and 'non-iterative' nature. When working in waterfall you need to know your objectives beforehand, defining the steps necessary to reach your end goal. A good way to plan for these additional mixing

Table 2.1 LOQ Mix

	L0	L1	L2	L3	L4
Definition of done	Concept phase.	Prototyping phase.	Functional phase. Playable. Basic audio-visual representation should be available in the game.	Shippable. All systems in place and audio-visual realization fully available in the build. Design balanced.	Final quality.
Mix definition	Mix vision, references, targets or 'previs' videos created. Mix guidelines documented. High-level design written, documented, and communicated to all relevant teams for any mixing tools needed. Creative brief and high-level design for all mix-related accessibility features written, documented, and communicated to other relevant teams.	Basic macro mixing. Volume, frequency spectrum, and attenuations are in control. Prototyping phase started for any mix-related features and tools.	Full-on macro mixing. The game is mixed and reviewed on the go for all volume, frequency spectrum, dynamic, acoustic, priority systems, and attenuations. The base mix is stable and maintained. Mastering is functional to control peaks and loudness of the overall game. Mix-related accessibility features are implemented and functional.	Full-on macro mixing. Systemic snapshots, systemic side-chains and other prioritization techniques have been tuned. A few 'focused' mix passes should have happened already on the game 'golden path' to demonstrate the final mix. Mastering and mix-related accessibility options are implemented thoroughly. The game mix is stable and optimized.	Final mix, final mastering, optimizations.

	L0	L1	L2	L3	L4
Mix owner involvement	Full involvement.	Very little on the actual mix. Primarily prototyping and iterating on design and implementation of mixing tools with tech partners.	Focusing primarily on reviews, listening session, providing feedback to the team. Also involved in developing mixing tools with technical partners.	Full involvement. Maintaining the macro mixing through reviews and supervision with the team. Micro mixing of the 'golden path' has started on a limited controlled scope.	Full involvement. Entire focus is on waterfall game mixing, artistic choices, and final mastering pass.
Audio team involvement	Very little.	100%.	100%.	100%.	Very little. More of a supporting role.

passes is to make a roadmap and retro-plan your mix goals before any important milestones, internal or external.

> 'It's important to work in broader strokes to begin with and then more refined passes as you go along. Getting bogged down at the beginning with very slow-paced detailed work is the key to disaster. Even if sometimes we can't circle back, every mix is about prioritizing and compromise'. (Tim Nielsen)

Those mix passes can then take a week, two weeks, four weeks, or more, depending on your objectives and milestones. The important point is to allow more time and resources for any player-facing milestones (versus internal ones) as those are generally more important. For example, if you're doing a mix pass for a vertical slice, you will be focusing on that part of the game only, from a player perspective, to make it shine. If you're on your last mix phase before release, you would need to play the entire game (e.g., for an open world type game, at least the whole campaign and important side quests as well as open-world activities), and focus on detailed work. It's all about polishing your mix to improve the emotional engagement your soundscape is providing to the player experience.

> 'The final mix can be crucial to quality and should be less about dialing in volume and all about polish, making those micro mix tweaks that create a consistent experience across the game, and highlight the emotions we want to emphasize moment to moment'. (Brad Meyer)

If your game has very long development cycles with more than a year between milestones (i.e., first playable version, vertical slice, Alpha, Beta, early access, gold, etc.), then perhaps try to plan for a quarterly waterfall pass to give a quality boost to your game mix (and de-risk other micro mixing phases). If you are not sure about how much time you need, try to time-box your time on a per-goal basis. You can also of course talk to your producer to evaluate how much time is acceptable from a production standpoint. Play safe and ask for a 20–30% buffer on top of what you've planned or what you've been given. After a few first micro mixing passes, you may be able to better define the time needed for future passes.

'I always work on securing a mix plan as early as possible. This means getting an agreement with the stakeholders about a mix schedule. Getting enough time for that will require negotiation and mutual trust'. (Loic Couthier)

Set goals for any mix sessions

When working on your macro mix, getting things under control 'on the go' within the agile scrum method, you would mix anything that has been recently added in the build. You are following the tasks and sub-tasks from your backlog on a sprint basis. But when entering a micro mixing phase things work a bit differently as you're mixing the game in a moment-to-moment way. Those mix passes could be fairly challenging because there is usually a lot to do in a short timeframe. You will need plan and focus.

'I like to give myself a schedule when mixing. I'm usually splitting the game into sections, so I know what has to be achieved per day, and I'm constantly reviewing from a "what is the player feeling" point of view'. (Adele Cutting)

Don't start a mixing day without having a clear plan of what you want to mix and how you envision making it sound in the game. There will be enough mixing distractions and other things popping up to fix along the way during those mix sessions: you will likely find bugs, random problems in the mix, or you might have some last-minute feedback on some of the contents, systems, or on the macro mixing of the game.

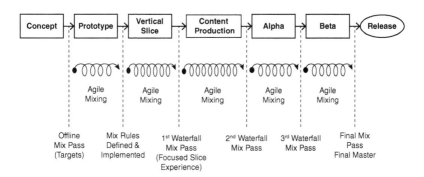

Figure 2.2 Mixing with the agile and waterfall methodologies

While you should have a clear broader objective for each waterfall mix phase, breaking down this objective into sub-goals that are achievable on a per-day basis (or half day, or weekly) will help a lot to keep focus. Focus is key to be as efficient as possible. Don't try to fix everything at the same time! When spotting something that sounds off but that is outside of your daily goal(s), take notes, add to your backlog, and plan to deal with it later. You could even dedicate a few hours or days during your waterfall mix phases to fixing and addressing feedback.

> 'Every day I'll map out ideally how far we should get through the project. Maybe we all agree, today we want to be through the first seven minutes of the film. We build out a roadmap spreading the workload across the available days and try and come up with a game plan. This is crucial'. (Tim Nielsen)

Put together a mixing taskforce

Even though there is one person who owns the mix and ensures the vision is delivered, putting a team together for your micro mixing passes is a crucial part of getting more perspective on and nuance in the mix work. Don't try to do it all alone: you don't have to! It's always good to keep an open mind and to embrace collaborative work.

> 'When mixing, someone else can pick up on a problem and may have a solution that the mix person hasn't thought of. This is why collaboration is so crucial. In my opinion everyone on the mix stage should have their opinion and share it if they think they can improve the mix'. (Tim Nielsen)

Having folks in the back of the room supporting you, taking notes, and providing feedback on the fly can be useful. Audio people who have worked extensively on some of the game's features might challenge some of your mixing choices, opening up interesting creative discussions. They will of course also bring their experience in designing and implementing some of the systems. It's great to get

this kind of expertise in the room when mixing as it is not uncommon to have to circle back to the content creation or implementation, refactoring a few things during the mix process (even if refactoring is something you may want to avoid during late micro mixing phases).

> 'I always work in parallel with a team when mixing, and the team is super agile. When mixing if I ask something to be changed or updated they turn this around super quickly so I can pick it up and carry on with the mix. Even though I'm the one mixing it's always a team sport'. (Adele Cutting)

As part of your mix taskforce, a good practice is to have someone else play the game for you while you're mixing or listening to your mix. It is a priceless time saver. It is also great for efficiency and focus, as you won't have to do back-and-forth between the gaming controller and the mixing tools. That person does not have to be part of the audio team, it could be a QA tester for example, knowing the ins and outs of the game, and having the ability to play it in an expected way.

Part of the work of mixing in games is also about involving and engaging with people from time to time for some play-through and listening sessions. Ask others to take your seat in front of the screen and play the game: things to adjust will likely come up more naturally then. Seeing different people play the game will also allow you to oversee different gaming behaviors, and stress-test your mix, as there's always more than one way to play a game.

> 'I like to adopt a more collaborative team mix session at the end of every milestone, because not only does this help us dial in the mix with a more comprehensive set of ears, but it also keeps the team aware and engaged in the mix process and generates new ideas to push both design and the mix in new ways'. (Brad Meyer)

Get access to a large variety of playback devices

Having or requesting the necessary listening devices and environments is the strict minimum when it comes to planning the resources you

need to craft the mix of your game. Try to keep in mind what will be the main playback devices used by players for your game. At the end of the day you have a target audience and you're performing for them. The best mixes often result from taking the player's playback devices into account. It's of course more challenging when you target a large audience using a wide range of speakers and headphones, but your mix should ultimately sound good and deliver clarity on all targeted devices.

A good practice is to always use the same setup when you mix your game (usually the higher-end one you have access to), but also allocate time for play sessions to test your mix on as many settings as possible to ensure a consistent listening experience for your players later on. Your ultimate goal is to provide as high-quality a mix as possible for a broad audience. So on top of your high-end studio monitoring, try to make sure you have access to a wide range of monitoring options, both pro audio and semi-pro or gaming. Then try to use the most common or expected players monitoring setup during your listening and play sessions.

'Mix in a professional studio to create the one 'true' mix, but also try to listen in other studios from time to time to evaluate how your mix translates to other setups. You should also set time aside to evaluate the mix on semi-professional configurations, as well as on more consumer-orientated setups'. (Ben Minto)

Chapter 3

Game audio mixing basics

Mix at the right playback level

Your mix will be perceived differently based on its playback volume. Try to mix at a volume that matches the listening level of most players to ensure your mix does not sound 'off' at an expected volume. Reference listening levels are well established for motion pictures (85dB SPL) and for Blu-Ray and DVDs (79dB SPL). The gaming medium is closer to Blu-Ray and DVDs for console and PC gaming (because playback typically happens in a similar home environment, and on similar platforms); a commonly adopted monitoring level is 79dB SPL. Things can be approached differently for handheld consoles and mobile games, aiming at a lower monitoring volume. However, if you feel that this reference level does not work for you, the most important thing is to aim for something that feels comfortable when working on your mix. Don't hesitate to set your own standard, aiming at something not too quiet or too loud. It can also greatly depend on the contents you are mixing during a session. Mixing explosions, weapons, or other high-SPL sounds at 79dB SPL all day can be tiring, so don't hesitate to lower your playback volume a bit at the beginning of any sessions that can be fatiguing for your ears. One key point is that once you set your playback volume at the beginning of a session, stick with it for the rest of the day.

> 'Having a main reference level that you and the whole team are familiar with is great, but also evaluate the mix regularly at levels that others might use (i.e., have a few reference levels: 85dB, 79dB, 65dB)'. (Ben Minto)

During play testing and listening sessions, it might be good to test your mix at lower volume, aiming at normal conversation volume

which is somewhere between 55 and 65dB SPL to ensure the main elements of your mix don't drop out, and that your mix is still as impactful at lower volume. More and more people in the industry actually use that range as their norm for their mix session. Testing your mix at a louder (but yet controlled) volume can sometimes also be beneficial. Human sound perception is not linear so the ear response varies with frequencies. Listening at higher volume increases the perception of the low-end and the high-end. Listening at higher volume can help to highlight harshness in the highs and imperfections in the lows. Listening to your mix louder would then also make your mix feel more powerful and rewarding. You could use that to your advantage when you plan to have executives, press, or other special guests coming to the mix stage for a review. Aiming at a theatrical volume of 85dB SPL can be the way to go in this case to impress your guests.

Finally, one of the most important take aways here is to protect your ears. Make sure you can still perform in 5, 10, 15, or 20 years. Keep in mind that after four hours of mixing at 95dB SPL in a day, your hearing is considered at risk. The same is true if you are working at 90dB SPL for more than eight hours. Either the motion picture standard of 85dB or the Blu-Ray/DVD standard at 79dB (and anything lower) should keep you safe.

Consider your screen size

Similar to your listening environment (acoustic, playback level, and playback devices), it is important to perform your mix on the correct screen size. It might sound obvious, but the size of the screen you're using for mixing can alter how you perceive things. It can then indirectly alter how you would want to mix your game. Even if it feels nice to have a fancy cinema screen or a large TV in your mix stage, if your game is made for mobile phone or handheld consoles, then try to get access to a screen of that size to perform your mix instead. For console games aim for a TV, for PC games a monitor, etc. Performing on the right screen size is all about getting the right feeling when it comes to the sense of scale, the power, the energy, and the perception of distance, to deliver a mix that feels right.

Listen to your mix at different positions in the room

While you want to work on your mix from the room's sweet spot (so you can listen and perform in the best mixing conditions, with a beautiful imaging and the most accurate frequency response possible), when

mixing for home entertainment you must consider that people won't always play the game and listen to your mix from the best listening position in their living room. Besides testing your mix in different listening environments, try to also take a moment in your sessions to listen to your mix from different positions in the room to evaluate how it translates. Make sure the mix still provides the necessary clarity and engagement and that nothing is getting completely out of control. This is more important if you are mixing for console games, as it is easier to anticipate the listener's position and distance to their speakers when mixing for PC games, handheld consoles, or mobile games. If your company (or client) allows it, try to test the mix from your home environment. If you cannot, perhaps ask to set up a 'play room' that would re-create a living room environment in your studio to test the game.

'If you can, take your mix home to experience how people are more likely to hear it in a non-professional consumer environment'. (Ben Minto)

Always mix and test in context

Mixing is about making progress toward having a shippable product by building a balance between different sonic elements, improving clarity and adding consistency in the overall soundscape. It is ultimately about mixing things together in a specific context instead of mixing individual elements separately. Sounds can be perceived very differently depending on the visuals, the narrative setting, or the gameplay contexts. Always make sure to pre-mix and mix your game and individual features in context. While there are a few things you can do with sounds being soloed or in test levels, you'd always want your mix to speak to your players on an emotional level. Self-contained test-levels are not great for that. Don't spend too much time trying to make single elements of the mix sound perfect in solo or out of context: players will never listen to your sounds in isolation.

'No matter how amazing the implementation is or how fantastic the sound design and speech may be, a bad mix can kill it. Conversely, a great mix can make a more simplistic audio approach, with less than stellar audio content, sound good to the player'. (Gordon Durity)

Make sure your contents sounds right at source

While context is everything when it comes to mixing, getting your contents to sound right at source is also key. Always try to record, create, and process your contents like there would be no live mixing involved later. When recording music contents for a record album, the quality of the recordings, instruments, and vocals alike is half of the process of getting a great mix. Things are no different when it comes to games. As much as possible, the contents should work out of the box in the mix without too much additional processing in your audio engine. Before exporting contents from your DAW and prior to implementing them, make sure you are consistently mastering them, at least per type of sounds (or sound categories). This becomes even more important in large collaborative teams, and for long projects that are developed over many years. You need pre-established mastering rules. The benchmark mix contents and mix guidelines extracted from it that should have been done during preproduction will become very handy here. Once those guidelines are clearly defined it is easier for anybody in the team to apply mastering processes, which often results in getting things sounding pre-balanced right away in-game.

> 'It is very useful to have the content created at established volume levels and frequency zones for audio asset categories. For example, big impact effects, background airs/tones, main dialog, loud emitters vs soft emitters, etc., should all adhere to general asset creation guidelines. When the raw assets are imported in the game engine, their relative levels, already established, should allow the game audio to start almost mixing itself once implemented'. (Gordon Durity)

Content mastering goes beyond calibrating volumes: it is also about frequency spectrum, wideness, and dynamic. When mastering contents as part of the creation process, you can directly hear how the assets are affected. You will hear background noises and other things you might not want in your assets. You then have greater control to correct things that will pop up during the process in your digital audio workstation prior to implementation. It is all about aiming for quality and clarity in your mix so even if you feel you don't hear a strong difference on individual contents, every single quality effort in your audio pipeline will make a difference on a larger scale when lots

of sounds are playing simultaneously and being processed live in the game. For example, while you could live with a little noise sometimes, you might ultimately need to get into noise reduction, as it is not uncommon to find undesirable background noise when mastering your contents. Make sure you're using a plugin that was specifically designed to do the job for more efficient and natural sounding results.

> 'For content mixing and mastering, I generally prefer to define general loudness of categories of sounds before bringing them into the engine'. (Brad Meyer)

In the eventuality that you are spotting unwanted noises on individual assets that someone else in the team created, make sure you talk to the audio folks who crafted those assets and show them what went wrong. Mentoring and sharing your processes will allow you to gain precious time and get higher quality input from everybody in the team later on. Consider mixing mentoring as a time investment.

In the unfortunate scenario that the team did not work with guidelines, or haven't cleaned and mastered their assets when you started the mix, it would then be preferable to allocate extra time to go through all the contents of the game individually, and run both a clean-up and mastering pass offline (i.e., in your DAW). It might sound time consuming at first but it's an investment that will make the rest of your mix faster, cleaner, and more efficient later on.

> 'A lot of the mix quality comes from the assets. An excellent mix of poor content will still be perceived as poor. Replacing a sound can often fix multiple mix problems much better than any processing. I like to "mix at the source". I review content with the final mix in mind'. (Loic Couthier)

Work on your volumes first and foremost

Mixing is much more than getting the right volume for all your contents, but getting your balance right between the different elements of your mix is an important step in the mixing process. Take the necessary time to work on your volumes first and foremost to get your levels balanced correctly before getting busy with other live equalizations,

compressions, or other effects. It will make your life easier later when working on frequencies and dynamics because you will have a clear vision of what you want your mix to sound like in any given scenario.

> 'Setting levels on sounds so they're balanced across categories and across the game is very important, as this is where a good mix starts; but there's a level of design and creativity that goes into the mix as well'. (Brad Meyer)

Getting the levels right for any sounds during the macro mixing phase of a game is a collaborative team effort. Sometimes, it can happen that when implementing audio contents in the context of the game, you realize that you need more granularity than anticipated. Even when working with mastering rules and spreadsheets, the mixing person should take ownership of making any necessary adjustments to create greater impact and build a stronger engagement for the player experience in the overall game soundscape. A few dBs up or down can make a huge difference in a mix, especially in games where a large amount of sound layers can be playing randomly and simultaneously. During macro mixing, don't hesitate to update your guidelines documentation and communicate this to the team if you feel it's necessary. Nothing should be entirely set in stone, especially if it does not provide the desired results. For example, people have a natural tendency to be more perceptive of sounds that are too loud in a mix, so when you feel that something sounds off in the context of the game, start by lowering it in the mix: it might just be too loud.

> 'It's important that when sound is added into the game it's added so that the volumes sound roughly correct immediately as otherwise you'll regret it. Don't wait until the end, make sure right from the start you're making sure the levels are as accurate as possible'. (Adele Cutting)

During micro mixing, a similar process can apply. As many things should already be under control in the overall mix, you're reaching the point of making the strongest artistic choices based on moment-to-moment gameplay. It will be time to break the rules to add more impact to your soundscape for special cases. During micro mixing, the guidelines don't really matter anymore, and one of the first steps

is to tweak the volume of different sounds or categories of sounds, or to remove or mute some of them entirely to leave space for the more important ones, creating further contrasts in the mix.

When in doubt on a sound (or a category of sounds), lower your volume fader all the way down and bring it back up gradually

In the absence of mastering and implementation rules or guidelines, for example if audio was not involved in preproduction or if the person in charge of the mix joined the project too late without enough time left to set those benchmarks; or when some sound elements don't seem to fit in the mix instantly or over time (replayability), it can sometimes feel hard to keep perspective on what is too loud or what is too quiet. Some sound types can also be more challenging than others to mix because of their omnipresent repetitive nature (for example player Foley). This can be especially true during macro mixing when you just created a batch of sounds, implemented them in the build, and also needed to pre-mix them right away. A simple technique after crafting and implementing contents is to lower the volume all the way down for any elements you've been working on. Take a break or move on to something else, then play the game in context and move the volume fader gradually back up until you find the sweet spot. This simple technique can also be used during long micro mixing sessions if you start losing perspective on the mix while testing creative ideas.

Use a hardware controller (or don't look at the volume fader value) when tweaking the mix

Having a hardware control surface for mixing is great (i.e., a midi controller connected to your audio engine), because it is tactile and you don't have to look at your playback levels. While you want everything to be implemented and pre-mixed following your mixing guidelines as much as possible during the macro mixing phase of a project, when entering a micro mixing phase you might want to work more by instinct, only using your ears. That means that you may want to move away from your mastering and implementation guidelines, to work on providing more contrast and emotion with your mix in the contexts offered by the game. If you don't have access to a hardware controller, another way of not being influenced by a number you see

on a meter is to not look at it when moving your virtual faders. Just look at the game to hear and get a feel for the sound in context, and move the volume until you feel it provides the right level of engagement in the mix.

Mix things over time to keep your mix alive and interesting

Independently of working on a 2D or 3D game, your game mix will likely be made of multiple volume, equalization, dynamic, or auxiliary sends 'automations' to create a nice sense of space in your soundscape. Another aspect to consider when mixing a game is the concept of modulating sounds over time. The idea is to keep things alive and interesting while fighting the feeling of repetition that can make something that sounded great become boring after a while. Player character Foley is one of the most obvious examples. Independently of the amount of variations per surface, per speed, per action (moving forward, backward, sideways, etc.) it can often feel challenging to mix Foley because it plays all the time when the players move their character in the game world.

> 'One thing I've learned from watching films is utilizing the sonic equivalence of an establishing shot. For example, when entering a new location, the sound can inform the player about the sonic environment they're in, and as soon as this is imprinted in the player's mind, we can start gradually deviating from it without changing their sonic interpretation'. (Martin Stig Andersen)

Building a volume or equalization automation based on a time variable for the different Foley layers can then allow you to organically make them feel engaging in the mix while gradually having them take a back seat to leave space for other sonic elements in the soundscape.

> 'On *Ghost of Tsushima*, Senior Sound Designer Josh Lord came up with the idea to start mixing character Foley and horse saddle/bridle movement down a few dB over time after the player had been running for more than 10 or 15 seconds. It was a subtle mix choice that helped prevent character movement from getting fatiguing, and allowed the rest of the world to come back into focus'. (Brad Meyer)

The player Foley might also need to be perceived differently in different contexts of a game, from an experiential perspective. Mixing over time can also be about providing a mix that is more dynamic by playing with automation on your sounds or effects to add further subtle changes in your mix with the aim of highlighting the feeling of a character, or to induce an emotional experience as well as a physical sensation moment to moment. For example, you could want to increase the sense of claustrophobia in an indoor space over time, or when the character is making progress within that space. Such technique can be achieved by adding 'zones' or 'volumes' within a predictable path that would set variable(s) changing your mix over 'time'.

Those subtle perception changes in the mix will often also become even more interesting if played with contrast. You could deliberately decide to make a moment in your game become sonically flat, 'boring', or repetitive, to provide a stronger effect in a following moment where things will change dramatically.

Work closely with other disciplines to improve the mix

Mixing a game goes beyond working on modulating and processing audio signals. An important aspect of game mixing is the collaboration that needs to happen across disciplines. The balancing of gameplay features directly impacts how the mix is perceived. For example, in a player versus environment (PVE) shooter with combat arenas, if you have nine NPC enemies spotting the player and all shooting at the same time, that combat instance will sound very chaotic. It will be hard for the player to read the information. If those nine NPCs were divided into squads of three, things could already be improved as three might be shooting at the player, three might take position, and the other three might be reloading or doing other actions. The way those enemies move, the way they behave, and their shooting patterns all impact the soundscape. It makes the work of the mix owner easier or more difficult depending on the situation. On top of your audio prioritization systems, a balancing collaboration needs to happen with design, and with other disciplines like animation or VFX. That balancing step is an essential part of your game audio 'edit'. Audio and mixing awareness, as well as close collaboration with other disciplines, is key to delivering a good sounding mix.

> 'Sometimes, it is the actual gameplay balancing that you need to influence. Fixing things might require you to influence the source and talk to other disciplines. Mixing scope goes way beyond the audio discipline'. (Loic Couthier)

Talking to: Adele Cutting, Audio Director and Voice Director

Adele Cutting is a BAFTA award-winning audio professional with 20+ years' experience in directing actors, audio direction, designing sound, music editing and casting, and covering all things audio across games, TV, installations, mobile, VR, and audio drama. Before founding her audio production company Soundcuts in 2011, Adele spent 15 years at EA, working her way up the ranks from Junior Sound Designer to Senior Audio Director. Adele has worked on titles such as the Harry Potter franchise, *Populous the Beginning, Theme Park World, The Quarry, Assassin's Creed Odyssey, Immortals Fenyx Rising,* etc.

Before starting to get hands-on with the mix of a game, what's your process and methodology?
The most important thing is to understand the game: what's important and needs to be heard? What are the key elements of the game? What does the game need the sound to do? Sound has so many different functions, like telling the story, making sure the story and dialogue are clear so that players know what is going on, making the characters feel alive, giving objects in the world weight, informing the player of the characters' emotions, hinting to the player that a threat is present, letting the player know if they've been successful/unsuccessful, helping create story arcs, creating the world/location, etc.

Once you know the purpose of sound in your game, make sure you have an idea of the audio systems that you'd like to employ game-wide for your mix, and think about this right at the start of the game development, as they can be difficult to shoe-horn in half way through, without causing multiple knock-ons.

The mix is ultimately about making sure that you can hear everything and that nothing is inappropriately too loud or too quiet, that the sound isn't distorted and peaking, or overall too quiet, and you can hear the dialogue clearly. The end goal is that all your intentions for the sound are clear.

Time management is crucial for a good mix. How do you make sure you are as efficient and as fast as possible during a mix day?
I'm lucky that I don't have a problem concentrating and can literally go for hours without a break, just because I really love what I'm doing and get into it. The flip-side of this is that I'm also not very good at switching off either...

I like to give myself a schedule. I work a lot on Narrative games, which are probably easier to manage planning wise. I'm splitting the game into

sections, so I know what has to be achieved per day, and I'm constantly reviewing from a 'what is the player feeling' point of view. If I get stuck on a scene, or if something is just not working, after a certain point I move past it. I can't stay on it forever, I'm working on a timescale, so I stop, I move onto the next bit and come back to it. I'm fortunate that the times this has happened, when I'm working on the next bit, suddenly the penny drops on a solution to add drama to the bit I was struggling with. Audio is the end of the chain, and in addition to everything else the audio is meant to be doing, if an edit is sluggish it's down to the audio to help with the pacing.

The team I work with is super agile, and when mixing I know that if I ask something to be changed or updated they turn this around super quickly, so I can pick it up and carry on with the mix. So even though I'm the one mixing it's a team sport.

It is quite common that important mixing passes happen during stressful times. How do you deal with intense situations, keeping your head straight to make the right mixing choices?
Practice and isolation. I'm sure at the start this used to completely stress me out; maybe it's because I've gone through the process so many times now that I'm used to the pressure in these situations. Although mixing is always in an audio director's 'plan', games change all the time, there's feature creep and potentially missed deadlines. Audio is at the end of the chain, so the audio team really feels the pinch at the end of the game, which is when you want to tackle the 'final mix pass'.

I find personal time management keeps me calm, so I have to set myself a daily target. Once a level is mixed I'll video the level. If I get an idea on something, I'll note it down and go back after I've achieved my target for the day. I will then start the next mix session by playing the previous level, and recording it into the next level. I record my play-through to play back and analyze what I want to do with the sound, and record additional play-through to check. I have a running commentary in my head. Does this sound good? Is it dramatic? Is it believable? I'm very pragmatic, and have an attitude which is 'let's crack on', and I've started so I'll finish.

During a mix, I also tend to ignore all messaging systems (email/Slack/Skype/Teams etc.), let the team know I'm mixing (so they know to look out for any urgent items I may need turning around), and then check to see missed emails/messages at lunch and mid-afternoon.

What are your different steps when mixing a game?
I start by checking all assets have been integrated into the engine or middleware balanced within their own category and implemented so that they

sound about the right level in-game. Things should never be added 'just to be in' and to be 'sorted out later', as that's just creating a whole world of problems further down the line. They should be 'in and fine'. A basic metering structure should be in, to avoid issues like dialogue being completely drowned out by music. Then I am making sure game wide that the work is well front-ended: any specific effects we want game-wide like low pass filtering effects, specific mix changes tied to gameplay events, etc. I will be watching a whole host of references. If I'm working on a horror game, I will literally always be watching horror out of work and taking note of scenes I like, and why I like them from an audio point of view.

Because I'm working a lot of narrative games (this is very specific to this genre), the most important thing is usually speech, so I will work through every level of the game with only speech playing, to make sure that it is consistent across the game: that whispers are not super loud, shouts aren't the same as normal spoken levels, etc. Working on that one area, making changes to compression, making sure the reverb/FX levels are correct, so that you can play from start to finish and the entire dialogue soundtrack feels right in terms of level and space. Then I iron out any problems that haven't really arisen in the editing process, but have now become apparent once in-game reverb has been applied. Then I move onto the ambience and mix this appropriately for the location around the speech. The ambience is not a 'constant' like the speech, as a super windy mountaintop is going to be a lot louder than crickets, but they all have to work around the dialogue. I will also be paying special attention to mix details between different speaker arrays (quad/5.1/stereo etc.). Then I move onto the Foley, then SFX (real world sounds, like doors, etc.), and finally the music and cinematic sounds (like sweeteners, booms, risers).

Cinematic sounds have to work with the music and they're non-real world sounds. Quite often music and those sounds are trying to do the same job and are working the same way, so this makes me question are they both needed? Can I get rid of one? If a sound isn't needed, just get rid of it, as it's just taking up space in the mix. You only want sounds playing that are needed. It'll make the mix cleaner. If both of these elements are doing the same job why do you need them? Is it to heighten a specific moment, does it represent a 'character' in the narrative, or is there another creative reason to use both?

As all the elements are now in the world, I'm not just listening to volumes, I'm listening to the frequency spectrum as a whole: are there too many mids, too much low-end, what is contributing to this? And making creative choices on whether sounds need to be EQ'd at source or in-engine or removed entirely. Also changing attenuations, changing the

distance at which the sound becomes audible, or how the sound changes over distance, etc.

An error I made when starting was just to make things that needed to be heard louder and louder, until I ran into problems with peaking; now I've learnt that removing assets or using EQ around the sound or framing the moment is a better mixing approach.

Ultimately I use the mix as part of the creative process, not just a 'leveling' pass at the end of the game. Yes, that's part of it, but by doing it, it leads to further inspiration on how to frame moments.

How do you define the focal point(s) for a game mix, and how do you build and prioritize your mix around this/those focal points?
Listening and removing unneeded sounds is the most basic mixing technique that I'd use when taking the mix of a game project. Taking out sounds that are not adding to the experience (everything doesn't need to be heard all of the time, plus it muddies the mix). Looking not just at volumes, but also EQ, FX, and attenuation of sounds, clearing space so the sound can breathe, and that it's a smooth and seamless audio experience that reacts to game mechanics and brings the world to life. This is literally all I'm doing, playing – creatively removing sounds to add focus (or finding elements I need to add to create drama). Finding the audio narrative within the mix is an important creative step. It's about adding clarity and defining moments.

The focal points can be certain elements important in the gameplay or the narrative, crucial information for the player, and some are systemic while some can happen per-scene and be an individual moment rather than a 'system' (i.e., changing the ambience mix on a specific event).

As the mixing stage is so focused and intense, this is the polish; I use this time not only to mix levels, add drama, but it's the final time if I require a sound to be changed that it is done during this process. So I'll quite often be reaching out to different team members to get them to tweak a sound, or add a Foley element. It's pointless wasting time trying to 'fix' a sound to work, when you can just quickly replace it.

To create further space in the mix, side-chaining and voice management are my preferred prioritization techniques. Ducking can often be quite harsh, as you can hear it kicking in and out, so I would reserve it for times when I've tried everything else.

Any last word of advice?
I think you've just got to go for it. Be prepared to make bold choices and if something's not working go back to the sound if it needs changing.

Be organized (files naming, bus structure, planning your days, etc.) and focused. Rely on your ears and your gut feeling: mixing is a creative process for me and not a technical exercise. Don't leave it until the last minute; make sure assets added go in 'as designed', not thrown in, as it'll be painful later.

Chapter 4

Mix bus structure

Aim at a top-down approach first

How you organize and categorize is an important decision in your mix process. As with any systemic work it is often worth getting started with a high-level design. Start with a large generic sound categorization (i.e., 'Ambiences', 'Player Character', 'NPCs', etc.). You can then break these into sub-categories to allow for more flexibility in your mix. This method is known as a top-down approach. For example, if you're working on a highly systemic first-person shooter, you are likely to have a 'Player Character' bus. This bus will then become the parent bus of sub-categories of sounds related to the Player Character, such as 'Foley', 'Weapons', 'Tools', 'Voice exertion', etc. Those sub-busses can then also be further broken down. You could split your 'Foley' bus into 'Footsteps', 'Footsteps sweeteners', 'Clothes' (or 'Body'), 'Rattles' (i.e., for when the character has equipped weapons or tools), 'Melee', 'Weapons Foley' (reloads, equip/unequip, scoping in and out, etc.), and so on. You could do the same for the 'Weapons' parent bus and break it down with sub-groups for each weapon archetype. How far you want to take it depends on what your plan is for the mix, and your personal preferences. Try to think about what effects you would want to apply to your busses based on all the possible mix scenarios. It's also worth anticipating how much signals modulations will be necessary to prioritize sound categories or sub-categories over others to modify further the flavor and focus of your mix based on different gameplay or narrative scenarios. 'Why?' is always the essential question when designing things and making decisions. Take the necessary time to think about the different gameplay scenarios and how you want to mix things related to that.

52 Mix bus structure

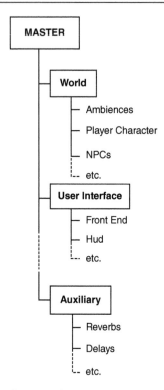

Figure 4.1 High-level top-down mix bus structure

> 'For my bussing structure, I start with the main categories of sounds. From there I'll create sub-categories, folders, or busses for child objects as it makes sense'. (Brad Meyer)

The top-down approach is efficient because it offers flexibility. In the previously mentioned first-person shooter example, you could modify the levels or processing of all the player character Foley at once, or only the footsteps (or other sub-busses of the Foley bus) without risking losing your balance by working on individual sound objects that should have been mastered and calibrated in the preliminary stages.

This high-level design phase will also ultimately help the whole audio team. People working on different contents or features would need to be familiar with the overall organization of your audio project. It's good to open discussions at the design stage as it can lead to identifying possible

edge cases. Brainstorming and peer reviews are always essential steps when dealing with systemic designs. The documentation will also be handy for new team members possibly joining the project later on.

The more modular the structure, the better

An important thing to consider for your bus structure is to aim at being as modular as possible. The top-down approach is efficient for this because it is relatively easy to add new sub-busses, to re-organize, or to remove busses efficiently when needed. It almost never happens that an initial bus structure is the exact same as you end up with when finishing your game mix. Things are always in flux when developing a game. It's fine to adjust your groupings along the way. You want to make sure to keep the door open for any new ideas during the game development. For example, you could have to make adjustments because gameplay features are changing, or because new features are added between the time you designed your preliminary sound categorization strategy and the time you are shipping.

> 'The more detailed you can be with your bus structure, the more fine grained you can get in your mix changes. At the same time, you want to ensure you're not making such a granular structure that you get lost or can't remember where your changes should be made or have been made'.
> (Brad Meyer)

Going back to the first-person shooter example mentioned previously, we can easily imagine the design team coming up with different status effects (things like 'poisoned', 'low-health', 'low-stamina', etc.) affecting the player character associated sounds in different gameplay scenarios. Keeping things as modular as possible will allow you to apply different effects and processing to your player character sub-groups. It will allow flexibility when crafting different aesthetic treatments for footsteps, clothing, rattles, etc. per status effect. Let's say the game design team decides to add a 'knocked out' status effect during the development of the game, where the player character is supposed to be dizzy but still has access to slow movement (i.e., walking is still enabled, but running is disabled). You could easily filter most of the non-player character specific busses to create a 'confusing' effect on the other game world sounds. You could also craft a separated effect for the player sounds, focusing on the footsteps to add weight and an 'inside body' resonance

feel that could work well with the reduced speed capacity of the player, using an EQ, perhaps a compressor, and a reverb effect on that bus when that status is active. With enough modularity in your groupings, you could also perhaps mute entirely the player movements, clothing, or armor sounds, and aim at another artistic treatment on the player voice and exertions.

When making changes to your bus structure, adding and removing busses, or when modifying the processing of groups and sub-groups, make sure to keep things up to date in your documentation. Also keep in mind that you always want to communicate any changes with the rest of the team.

> 'My bus structures tend to be quite large (usually a bit over 1000 busses + aux), because I like to be in a position where I can do anything I want, fast. Creating that bus structure is definitely not fast, but using it is'. (Loic Couthier)

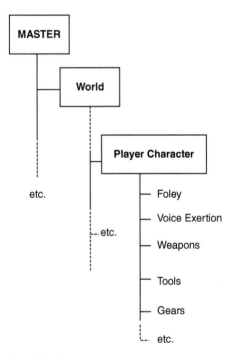

Figure 4.2 Mid-level modular bus structure

Categories and sub-categories of sounds can be mixed directly on the bus level

While the overall soundscape should feel in control with the pre-mix work done on the source contents and their corresponding implementation, the bus structure allows for working on the sound categories and sub-categories level. With a granular bus structure, you can use your busses or sub-busses for volume, run-time EQ and dynamic treatments, effects, and other adjustments with the aim of using a single fader to affect multiple sounds at once. Mixing categories and sub-categories of sounds on the bus structure is also handy to deal with how a sound category plays in relation to another. You could implement a lot of your mixing rules and logic on busses directly.

> 'I organize busses based on types of content that need a specific set of mix rules. Input × Mix Rules = Output. Inputs are the content. The mix rules are set on the busses. Output is the player-facing mix. I try to have a bus per input type, so every input type has their rules defined at the bus level (states, parameters, etc.). Routing a sound to a bus essentially means assigning it to a set of mix rules'. (Loic Couthier)

The category level mixing can also be used to make adjustments in your mix if you need to output different mix versions of your mix for different end-points. For example, if the game is being mixed in surround, and you also need to deliver a stereo mix, you might have to adjust levels on the categories level to cope with the loss of the center and rear speakers. The same idea could apply if you are delivering two stereo mixes, one purely stereo, and one binaural version for headphones. The 'binauralization' processing could affect how contents are perceived in terms of loudness or 'power'. Making adjustments directly on categories of sounds might be needed then. There is also a level of 'pre-mastering' that you could do on your busses if you aim at having less to do on your game mastering at the end of your project signal chain.

> 'When dealing with different mix formats, the stereo is usually the problematic one as it's the one where the center channel disappears, so it will sound very different. Stereo is just a compromise. It'll never sound as good as any of the surround versions, and we need to keep the dialog intelligible.

> So often the stereo raises the dialog and lowers everything else slightly'. (Tim Nielsen)

The bus structure can be used for sounds prioritization

There are different ways to achieve focus and clarity in a mix. But, as your busses should be a representation of the sounds categorization for your game, there is a lot you would be able to achieve with implementing run-time signal modulations on your busses to ensure the players hear more clearly the most important elements of your soundscape moment to moment. When designing and implementing your bus structure it can also be good to envision it as a branch in your priority system(s). Techniques like side-chaining, ducking, high dynamic range (HDR), or rules-based snapshots are often used on busses to play with subtle or more dramatic changes. This results in having to deal with prioritizing the signal of some sound categories or sub-categories over others. A good organization and categorization alongside precise use of modulations could do a lot of the heavy lifting work to achieve a clear-sounding mix.

> 'When drafting a paper design for my bus structure, I would often be thinking about what busses may side-chain other busses and how things might work behaviorally. It's a good exercise to think about this critical step early and can also inform better decisions down the road as your bussing structure grows'. (Brad Meyer)

Talking to: Rev. Dr. Bradley D Meyer, Audio Director

The Rev. Dr. Bradley D Meyer is an audio director who has been working in game audio since 1998. He started his professional audio career at Berkeley Systems, then Konami, followed by Shaba Games and Free Range Games. For the past 10+ years, Brad has been the Audio Director at Sucker Punch Productions on titles such as Ghost of Tsushima, inFamous Second Son, and inFamous First Light.

What is your first step when starting the mix of a game?
Mixing is a continuous process throughout the project, so the start of the mix is really putting that very first sound in the engine and setting its volume, its attenuation, etc. The next step is adding a second sound and mixing that relative to the first, and so on and so on. It's an additive process that entails incorporating and adjusting content both up and down relative to each other to maintain a coherent soundscape.

In regards to a final mix pass, we start with our core pillars. I may start with character sounds, solo them and dial in their levels against each other, and then unmute the rest of the mix and adjust the character bus level to sit back into the mix in the right place. We'll do the same for other core sets of sounds like combat, ambience, UI, music, etc. This can also be done as a sort of pre-mix before heading into the final mix, which if you have a big enough team can be a good way to get a head start on the mix and also shorten the amount of time you might need for a final mix (or free you up to spend more time making micro mix edits and polishing up transitions). Depending on the size of the game and how much pre-mixing you've done, dialing in the core pillars can take upwards of a week, maybe more. For mission-based games, after we've got the basic gameplay dialed in, we'll start playing through our mission content. We go through these based on priority and importance. If there's too much to get through in our time allotted, we'll focus on the content the player has the best chance to hear.

Game mixing often has two main aspects to it: content mixing and live mixing. How do you like to approach both aspects of the mix?
I've tried a few different approaches in my career for content mixing. Historically I had baseline normalization values for various types of sounds: UI, music, dialogue, 'core' SFX, and 'loud' SFX, and would normalize assets before bringing them into the engine so each group of sounds had a uniform starting point that sat well across the entire soundscape. On recent projects using Wwise and HDR, I opted to use the middleware built-in normalization and allowed the volume values set in the middleware to control their loudness in game. Normalization in middleware can be problematic, however, especially when needing to do sample

accurate transitions on sounds that are no longer uniform in their volume as they would be if you pre-processed them. It's still a valid technique, but I prefer to define general loudness of categories of sounds before bringing them into the engine. This is also important because some mixing techniques can instance limit sounds based on their volume and if you're having to turn down one sound in a category, say 6 or 12dB, to match the other sounds in that category, you can end up with sounds being rejected from playing when they shouldn't be since you're compensating for loudness in the wav files by adjusting their volume levels in the middleware which affects their behavior within the audio engine.

After the asset level content mixing comes the category level (bus, actor mixer, group, etc., depending on your middleware or engine). I usually try to dial these in fairly early in the game but will always make minor adjustments throughout production. I'll also create more sub-categories as needed to make mixing easier down the road.

Lastly comes the live mixing, which is often a series of micro mix adjustments tied to specific states or actions in the game. This macro vs micro mixing is a critical notion to understand and work on when mixing a title. Macro mixing is that general category-based level setting, while micro mixing is all the moment-to-moment details from volume to effects and filters, attenuation settings, etc. based on changing actions in the game.

For me the exciting part of game mixing is that live or interactive component. I try to set baselines for content and we do these pre-mixes to ensure everything is sounding good, but the real magic of mixing non-linear content is in the parametric control we have over the moment-to-moment gameplay experience. Being able to craft the audio experience based on any hook we get from the engine, whether it's tweaking volumes in a specific scene to emphasize sadness or adjusting the position of the listener over time to make something feel more claustrophobic, is the core focus for me when doing a mix.

It's also super important (and hopefully obvious) to mention that mixing is NOT just about volume; it's about every sonic characteristic of a sound. Pitch, filters, effects. All of these things affect how a sound or group of sounds fit into the mix, and changing them over time based on parameters coming from the game engine is invaluable to keep the mix sounding fresh and alive, reducing fatigue, and most importantly ensuring the most important sounds (either to you as the audio lead, or your creative director, or to the player) are the ones we are hearing at any given time.

How do you like to design your bus structure?
I like to keep my bussing, and entire project, as organized as possible from the moment I begin a project until the end. Good organization will save countless headaches down the road. However, don't be afraid to re-organize if and when it makes sense. Make smart changes, ensuring you're not going to break the mix,

but the more detailed you can be, the more fine grained you can get in your mix changes. At the same time, you want to ensure you're not making such a granular structure that you get lost or can't remember where your changes should be made or have been made.

For my bussing structure, I start with the main categories of sounds: ambience, characters, objects (things like props, breakables, etc.), music, UI, voice, vehicles, weapons, etc. From there I'll create sub-categories, folders, or busses for child objects as it makes sense. My main character bus may have sub-busses for hands, feet, movement (which in turn is split into clothing and gear); other categories of character sounds like combat and dialogue each go into their own sub-busses within those parent busses.

I always approach this bussing design from an organizational standpoint: what's going to be the most intuitive layout for someone new to the project and, concurrently, what's going to be the easiest way for me to achieve both macro and micro mix changes throughout production. The bussing structure itself really depends on the middleware or audio engine being used. Some engines afford unlimited bussing in which I try to be as detailed as possible, especially with child busses, while other engines only allow for a specific number of busses in which the organization needs to happen at other levels.

I mentioned paper design above because that is what I will often do when starting on a project, taking what I know about what the project will be and sketching out my initial bussing structure. Even to the point of thinking about what busses may side-chain other busses and how things might work behaviorally. It's a good exercise to think about this critical step early and can also inform better decisions down the road as your bussing structure grows.

Whether its busses, actor mixers, folders, or any other organizational tool within a project, I try to be detailed, but I also need reasons for adding new structures to my mixing hierarchy. Is this bus serving a purpose? Am I using it in some way, either to set levels for a group of sounds or to use as a mixing tool in mission or systemic content? While I often add new busses throughout the project as the need arises, I will also remove or consolidate those I no longer need or which seem extraneous.

When dealing with frequency bands, do you prefer to work at source or in-engine?
I do a lot of EQ in-engine. It provides flexibility and allows me to reuse or recycle content for multiple purposes. We're still not at the place where we have limitless memory in games, so sometimes using EQ is an efficient means to sculpt sonic properties of sounds without having to load in wholly new assets. For example, on PS5, I can take a sound in the game, and send it in parallel to an aux bus routed to a haptics bus with a low frequency boost at 50–90Hz and a high cut at 300–500Hz so I'm only sending the parts of the sound that will be

played back by the haptic motor and it maintains perfect sync with the SFX which feels best. Or I can take a sound like a footstep layer and EQ the low mids up a bit for larger characters so their movement has more weight to it.

I've worked on games before where playing back assets in the DAW or middleware sounded good but once we were on the mix stage we were noticing some really strange muddiness in the mix. Turned out a whole bunch of sounds had content around 30Hz in it! Rather than take all these raw wavs, EQ them in a DAW, bounce them out again, and re-import them into the middleware, we just added an EQ to the offending actor mixer and the problem was gone.

Using EQ to affect the mix parametrically is another technique I've used in various projects punching up the lows or highs and tying it to player level or other gameplay-related parameters. In *Spider-Man: Web of Shadows* where the player could switch between the red (heroic) suit and the black (brutal) suit, I applied a low-end boost on the black suit and a light high shelf for the red suit to emphasize the strength of the black suit vs the more acrobatic, less violent red suit during combat. I used a similar technique in inFamous Second Son that made EQ tweaks dynamically based on the player's karma that could change over time.

Another favorite for me is using EQ to affect the mix in a low-health state. The common avenue here is to use a low pass filter, and crank down the frequency as the player gets closer to death, but instead I'll use a mid frequency notch and widen the Q as the player grows weaker which has a very effective result in sucking the life out of the mix so all that's left is the mud of the low-end and sheen of the high frequencies with no base or structure to the sound as the player nears death. It's a more sonically interesting means to convey danger to the player than just removing high frequencies.

I also employ a lot of dynamic EQ when I can. I don't like the sound of volume ducking in a mix. It's usually VERY apparent, like turning down the music when the characters start talking, and I like to make my mixes as transparent as possible. So instead of ducking, I'll use dynamic EQ by side-chaining one bus to another and carving out the frequencies in one bus based on the input of the other. So maybe I want to carve out 2–3kHz in my combat when critical dialogue is playing to ensure the dialogue transparently punches through during combat.

Any last word of advice you would like to share with us?
People have their own technique(s) for mixing and what's most important is to discover and utilize what works for you and your process. Like every aspect of game audio, mixing is an ever-evolving process and one you should continue to learn from and experiment with throughout your career. You'll figure out some cool shortcuts or techniques that you take with you along the way, and hopefully you're continue to learn and push the envelope in inventive ways. Never be afraid to experiment and try new things!

Chapter 5

Sound prioritization

If you don't need to hear something, don't play it!

In game audio, the mixing person also often wears the hat of a sound editor. When crafting the soundscape feature by feature, the team creating contents and designing systems will generally go in-depth. They will often be focusing on small details and adding a lot of sounds and functionalities to make each feature sound as unique and as rich as possible in isolation. While those features might sound great individually or in specific scenarios, to reach clarity and focus in your mix you could end up mixing very quietly some of the sound layers, to a level that is barely audible. When that happens it usually means those sounds are not necessary in that specific context. The overall soundscape of a game can improve significantly if the mixing person takes the responsibility to remove superfluous elements of the mix depending on the different gameplay or narrative scenarios. It is then important that elements of the soundscape are created, exported, and implemented with mixing flexibility in mind. The mixing person would want to be provided with enough granularity in the systems and sounds layering to have the possibility to not mute an entire sound set, but instead only remove details that will be more interesting if not played all the time.

> 'Mixing is a lot about ensuring the most important sounds (either to you as the audio lead, or your creative director, or to the player) are the ones we are hearing at any given time'. (Brad Meyer)

For example, if you work on a game where the player character Foley is important to the experience, you might end up with a lot of

base materials (i.e., concrete, different types of metals, woods, grasses, dirt, mud, etc.), recorded with different footsteps performances (i.e., sneak, walk, jog, run, sprint, moving forward, backward, sideways, etc.), all essential to the core experience. But you might also have additional footsteps layers used to spice things up. Things like small debris, material resonances, rattles, etc. making the player movements sound more grounded, interesting, and diverse. While those added layers will sound great in the context of more quiet and intimate scenarios (i.e., when exploring the world, or in infiltration phases to keep players on their toes, making them more aware of the sounds their character is making), they might clutter the mix in dense and busy scenarios. For example, in a combat instance, those sweeteners are likely to be adding unnecessary 'noise' as those sounds would become inaudible. They would then clutter the mix on a scenario where you would want to provide clear and prompt gameplay feedback.

> 'A great mix relies on great editing. Implementation and culling is that editing stage in games'. (Loic Couthier)

The same idea can be applied to narrative scenes like 'cutscenes' or 'animated sequences' with dialogues. While you might want to provide the necessary 'world building' details in the ambient soundscape of your game, things like the sound of wind blowing gently on surrounding bushes or the humming of a generator around the listener don't necessary need to play at full volume or at full spectrum during a narrative scene. It could get in the way of delivering the story efficiently. The truth is: all those sonic details don't need to play at all times. Working on the pacing of sounds will both make them more interesting and make your mix feel richer.

> 'We often think of everything we do as an additive process. Add the dialog. Add the backgrounds. Add the music. But creative mix should equally be about refinement. If something can be removed and you aren't obviously aware of it going away, then it shouldn't have been there in the beginning!' (Tim Nielsen)

The role of the mixing person is to make artistic choices, and culling is one of the main aspects of this in game audio. Don't hesitate to

reduce the focus or mute entirely unwanted sounds or categories of sounds depending on the game contexts. De-clutter the mix and aim at always making sure that what is playing really needs to be heard.

> 'Clarity and focus are the goals above anything else. The most important thing is to support what the game is communicating at any given moment. A simple mix conception is cut versus boost, and cull versus add. To make something more noticeable or bring it into focus, try cutting things around it that may be clashing in order to create a space in the mix for that specific sound to play'. (Gordon Durity)

Get your focal point(s) identified and sounding right first to build the rest of your mix around

One of the challenges for the mixing person is to identify what is the most important sound or category of sounds to be heard by the players, at any given time. That's your focal point. The earlier you define your focal points – it is not uncommon to have different ones for different scenarios in your game – the easier it will be to build the rest of your mix around it. Your focal points vastly depend on the game's genre, its creative vision, the game design vision, the narrative vision, and of course the audio and mix visions. Ask yourself questions such as: What are the loudest elements of the soundscape? Which are the most important? Are those the same? Is there a risk of listening fatigue with those sound categories? If yes, what's your strategy to work around it? What sounds need to be clearly audible at all times? What sound types are key for readability in your game?

> 'In the games that I have worked on over the last ten years the focal point was always the story. That means the dialogue was the most important element of the mix, so we established the level that we want to hit for the various dialogue elements and we mixed everything else around it'. (Rob Krekel)

The focal point will in many cases be the more prominent element in your mix and often one of the most detailed ones sonically. Beware of making it so prominent that it feels disconnected from the rest of

the mix. Making something the central point of your mix does not mean making it the loudest. It often means culling other sounds of least importance playing at the same time to leave space for it. For example, if you work on a single-player third-person action-adventure game with shooting mechanics, your focal point is likely to be the dialogues. You'll get those to fit nicely in the mix first, and then build the rest of the quest mix around it. Firearms weapons will have higher peaks than the dialogues and will be 'louder' while still not overpowering the voice contents, so that the story can be delivered clearly. Crafting a mix around a focal point is generally done by using a combination of volume, frequency, dynamic, attenuations over distance, panning, wideness, layering, acoustic rendering, culling (voices or emitters), and using run-time modulation techniques (e.g., side-chaining, ducking, HDR).

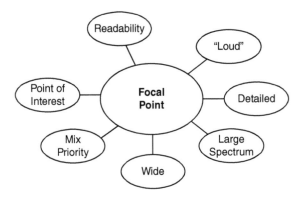

Figure 5.1 Focal point

Determine other priorities around the focal point(s)

Once you've defined your focal point(s) for the different scenarios offered by your game and the different play-styles associated with it, you can start thinking about the priorities you want to give other sounds. An efficient technique is to list the four most important sound categories around each identified focal point. Prioritizing means deciding where you want to put the focus in your mix, what sounds should always be heard, and which ones can be sacrificed in different contexts. It's all about anticipating what the player should be focusing on in all the different scenarios. Anything not culled outside this 'Top Five' (the focal point and the four most important sound categories around it) will be used either to deliver a consistent

sounding world (while taking a back seat in the mix), or culled entirely.

An efficient method is also to list down the sound categories that are not in that 'Top Five' but that should never be culled. If not already part of your 'Top Five'. For example, 2D sounds like music, UI, or HUD notifications are usually not expected to be culled. The same applies for sounds related to the player character as they should probably always be playing, but perhaps not all layers of sounds related to the player should be heard in all scenarios. It's also worth considering objects that are moving because they attract the eye (i.e., animated or visual effects based objects), and people would expect to hear sounds associated with those. If a moving object does not have sound, it could be considered a bug. It is all about sorting out things that could possibly be immersion breaking if not present in your mix, and things that could be disorienting for the player if not clearly heard.

Designing your prioritization scheme around your focal point(s) is an important step, and difficult decisions will likely need to be made. While you can try to anticipate as many scenarios and use cases as possible on paper or during brainstorming sessions, try to remain flexible and keep in mind that a lot of that work also happens over time while working on the game. Stay high-level when starting that design process, listing down your macro organization such as categorizing sounds per family such as 'gameplay', 'world building', and 'narrative' related sounds. It will make it easier to make preliminary decisions for the different game contexts, while keeping some of the lower-level decision making for later (often during the micro mixing phases).

Critical sounds take priority over non-critical sounds

Beyond your focal point(s) and the four most important sound categories per given scenarios, you also need to think about what sounds are critical and which are not in the mix. When dealing with audio emitters or voice management, you might decide to cull the least critical sound categories or sound sets within specific game contexts. When working with audio signal modulations, you will have to decide what sound categories or sound layer should take the lead in the mix in the eventuality that they all need to play at the same time (i.e., using techniques like side-chaining, ducking, HDR, etc.). In that case, critical elements of your mix would not be modulated, or only very gently (by sounds of higher importance within that context), while

non-critical elements would be processed more dramatically. For example, when mixing in-game music, you could split each of your music segments into at least two stems, a critical stem and a non-critical stem. The non-critical stems will likely have musical elements that are less important musically or more sustained (things like pads, drones, textures, accompanying strings, etc.), while the critical stems will have important music elements that would make your mix 'pump' or would take away the character of a song if strongly modulated (i.e., big percussions, main melodic lines, solo vocals, etc.). If you decide to use side-chaining as a prioritization technique, then the non-critical stems could be side-chained dramatically on volume, frequency, and/or dynamic by very important elements of the overall game mix (i.e., dialogues, weapons, explosions, navigational sounds, etc.), while the critical stems would be untouched or only using subtle natural sounding processing. If you were to mix a combat scenario in a busy shooter: gunshots could heavily reduce the volume and carve significantly the frequency spectrum of the non-critical music stem, while the critical elements of the combat music would only use gentle frequencies carving to leave additional space in the mix for guns. With such an approach, the overall combat music could still be mixed loud enough to build the necessary engagement from a player perspective without masking important positional gameplay sounds, and splitting your music segments into two stems treated differently at run-time will result in a natural sounding mix without a pumping effect. Defining what sounds are critical and which are not per sound family ('gameplay', 'narrative', 'world building') first, and then per sound category (i.e., 'music', 'player Foley', 'player weapons', 'enemy AI Foley', 'enemy AI weapons', 'ambiences', etc.), will help tremendously in making mixing choices based on the different game scenarios.

Adopt the rule of 2.5 as much as possible

While deciding what sound categories or sub-categories need to be heard in the different contexts of the game, it is important to understand the concept of limiting the amount of localized sync sounds being played simultaneously. The rule of 2.5 from Walter Murch that has been generally adopted in films is also applicable to games. This rule states that when there are more than two visible moving entities on-screen, the human brain cannot distinguish sync points or identify clearly sound positions anymore. When there are fewer than three audio-visual cues, the sync between audio and visuals needs to be perfect. To apply that rule in games, put it this way, the listener can

only process two thematic elements of a mix at any moment. For example if you have two NPC characters moving around the player and visible within their field-of-view (FOV), the footsteps Foley need to be in perfect sync and the listener will be able to read the action accordingly. If three or more NPC are moving around, then the player won't be able to distinguish from whom the footsteps sounds are coming.

> 'I subscribe to the Walter Murch idea of being able to focus on roughly 2.5 sounds at any one time. To this end we use all of the mix tools and techniques available to us'. (Gordon Durity)

Being able to localize and associate gameplay elements by sound is important to allow players to 'play by sound'. In games, complexity comes from the fact that you often have to communicate more than two or three gameplay feedbacks in a timely manner. The concept of entities is then crucial, as in games that rule often has to do with elements using similar sonic characteristic. In many cases this rule would need to be applied differently depending on the scenario and the context of your game, so you would need to create different sub-rules for your different sound families ('gameplay', 'world building', and 'narrative'). De-cluttering the mix and defining what are the two most important audio sources to hear at any given time is a very collaborative and sequential process. For example, if you want to improve readability in a sonically busy gameplay instance, you'd need to work closely with design. Everything from artificial intelligence behaviors, to enemy attack patterns (i.e., shooting patterns of full-automatic weapons in shooters to feel more natural and not crowd the mix with constant bursts), level design (i.e., for sound propagation), and distribution of enemy AI archetypes within that level design – all that matters to deliver a mix that is truly at the service of the game experience. Audio supports game design by improving readability, and for that game design needs to support audio to make sure the most important elements of the soundscape are heard. It's a two-way street. If we circle back to the previous NPC footsteps example, but this time with a large amount of friendly NPCs in a safe zone (i.e., a large indoor market in a role-playing game (RPG)); those NPCs will be living their life all around the player character, and their footsteps would be considered as 'world building' sounds. If you play all footsteps in perfect sync with precise panning, it will most likely end up

sounding bad. In that scenario, the sync and panning of those footsteps, as well as how many actual footstep sounds are playing, are less important than populating the game world with life, except perhaps for characters that are within the listener's FOV and at a relatively close distance. Creating an ambient soundscape with a sense of busyness with people moving around the space might be more appropriate. On the other hand, in an action-packed combat instance, with enemy NPCs running around, this 'distance + FOV' condition to drive the rule of 2.5 could apply, but you could also aim at using more complex variables. For such types of sounds you probably don't want your information to be lost, so you need to decide which enemy NPCs need to be heard. Distance (i.e., the nearest two) could in that case become a variable to define the threat level of an enemy, alongside other variables, such as 'NPC unit shield level', or 'NPC unit equipped weapon(s)', or 'is NPC unit in alerted state?', or 'is NPC unit actively searching for Player?', or 'did NPC unit spot the Player?', and the list of possibilities goes on. The rule would then be used by defining the most critical gameplay information that players need to hear, localize, and associate with an object or a character in the eventuality that more than two gameplay-related sounds of the same type with similar sonic signatures are playing simultaneously. Other sounds that are still playing will be pushed in the back of the mix, and used primarily to populate the soundscape. With that in mind, sounds associated to a sound family can also change dynamically based on the rule of 2.5. A sound with a 'gameplay' purpose can then become a 'world building' sound. For example, in a PVE shooter where you'd have a lot of enemies targeting the player at once, the most important two enemies' weapons should be cutting through in the mix, at least for a moment, while others should be present to populate the battle soundscape, and others could be culled. It becomes then a combination of culling emitters, voices, and modulating or processing the signals differently based on the rule of 2.5. The idea is to subconsciously tell the player what enemies they should take down first, or what actions they should take to make progress in any dense instances of the game. The rule of 2.5 in games is often about delivering a message in the most effective way and does not mean only playing two sounds in sync with accurate panning.

'I usually find it difficult to comply with the rule of 2.5 in games. There's often too much going on. I genuinely try my best to reduce the input

overflow and provide the minimum amount of info possible at a time'. (Loic Couthier)

The question can then arise about other gameplay elements of the same type happening outside of the listener's FOV. In movies, the sync of off-screen audio elements allows audio editors and movie directors to play with timings for the information to be conveyed in the most elegant way. In games, gameplay action happening outside of the FOV usually needs to be communicated to the players in a timely manner, as those can be more important contextually than the ones happening 'on-screen'. An important consideration is then to work on a chronological order of actions, the latest ones usually being those remembered more easily by players. When too many things happen in a gameplay instance, the rule of 2.5 can be delivered based on a series of actions (over time), focusing on what has been happening last in the eventuality that all the sounds that are playing have the same importance or priority. You could make the players feel that they've heard everything clearly all the time, even if they have not. You can think of it as an 'establishing shot' for audio based on the rule of 2.5. For example, in a competitive online PVP first-person shooter where multiple players could be shooting at the player (being a low-predictability mixing scenario), you could decide that only the two most threatening or dangerous enemies should be clearly audible in the mix. When one is not a high threat anymore (for example because one of those enemies is reloading or taking cover), another enemy weapon would take that spot in your mix prioritization. Your focal point would then be defined as 'the two most threatening weapons', being updated at run-time depending on the situation and enemies surrounding the player character.

When it comes to narrative beats, things can be a lot more convoluted. The approach is often worked 'scene by scene', based on the information and the associated emotions you want to provide. In the case of cutscenes with 'locked view', you could adopt the rule of 2.5 as is, as you're in a 'film context'. If the player has the possibility to move the camera around or to move their character, then you'd need to decide sequence by sequence what it is you want to play to grab the listener's attention, and possibly drive them toward points of interest or build anticipation for the next narrative beat that will happen in the scene.

Snapshots are efficient to deliver a clear and interesting mix that feels alive, changing the focus for different gameplay or narrative instances

When defining your high-level prioritization it can be too early to deep dive into drafting a fully-fledged design with all details for all different possible scenarios offered by the game you're working on. It is however never too early to start thinking about the main (systemic) scenarios and how you possibly want your mix to react to that. If you feel you need to change your focal point or your 'Top Five' for any of those scenarios, this means that you may eventually have to craft different versions for your mix. To achieve this, a commonly adopted technique in games is to use snapshots (also sometimes called mix scenes or mix states). Snapshots in games can be as 'simple' as a picture of the mix triggered by a single callback. These snapshots called from an event or a game-state can be very useful for creative mixing during micro mixing phases of your project. They can often be used on main quests or key narrative moments of a game with the aim of the mix providing a stronger emotional response in the listener. But snapshots can also be triggered by a more complex logic, especially for systemic games with low predictability, using a combination of multiple rules. Those 'rule-based snapshots' then greatly depend on the action (i.e., if 'X', 'Y', and 'Z' happens and you are currently in snapshot 'F', then transition to snapshot 'H' in X seconds, with a cross-fading time of X seconds). You could use both types of snapshot simultaneously for more granularity in your mix, making it more clear, 'alive', and interesting.

When using snapshots, the mix changes can be as simple as volume balancing changes on the bus level, or be far more complex with a completely different version of the mix being called (i.e., different attenuation settings, different processing of sound categories, activating and de-activating multiple side-chains, changing the prioritization, changing the spawning or culling rules scheme, etc.). Because snapshots can impact the entire mix of the game, a good practice is to draft an action plan and take things step by step, starting with a paper design to ensure you are building on top of solid foundations. The design phase is crucial, especially when dealing with systemic rule-based snapshots. Don't rush it. As with every important step in your mix, try to involve multiple people in the process, opening up early discussions that could offer interesting perspectives and opportunities for the mix later on. While it's key to be open to changes and embrace collaborative work, it is also important that the mixing

person already has an idea of how they want the game to sound in different systemic or 'linear' scenarios.

> 'I often start with a paper design when starting on a project, taking what I know about what the project will be and sketching out my initial bussing structure, to the point of thinking about how things might work behaviorally. It's a critical step that can inform better decisions down the road as your bussing structure grows'. (Brad Meyer)

As with any complex systemic design it can feel overwhelming to get started. You've already listed your focal point and four most important sound categories per scenario, so a good next step could be to write guidelines per systemic snapshot describing how you envision your game to sound. Think about how the snapshots will alter the player's perception of the soundscape. Describe your soundscape from an experiential standpoint, for example, how intense, dense, 'dry', 'wet', busy, or quiet do you want your mix to sound for those different scenarios. Consider things like contrasts, repetitions, and ear fatigue. Another thing that you can add to your paper design is a list of sound categories you do not want to hear in any given scenarios.

> 'Finding the right balance between tension and release is essential to give a sense of direction to the overall experience. Accordingly, I like to have intense moments but then also longer stretches of time where you hear only the most basic sounds, giving the player a moment to rest, and re-establishing a clear contrast to what's loud'. (Martin Stig Andersen)

It is ultimately a lot of self-questioning. What would you want to mix differently compared to the current base mix you have in your game? Do you really need to hear sound category X or sub-category Y in that context? What will you do to make sure your focal point is in the spotlight? There are a few more things that are important to add to your snapshots design. What are the necessary conditions to call any snapshot? Are there any possible edge cases? What is the expected playtime duration per snapshot (to make sure to keep intensity and ear fatigue in consideration)? What's the priority between the different snapshots (if any)?

While it might sound obvious, when you have the full first draft of your snapshot design with all listed 'Top Five' sound categorizations and trigger conditions, make sure you don't have any duplicates. It is not uncommon to plan for a lot of systemic snapshots, aiming for something too granular to then realize that you have multiple rule-based snapshots with a similar 'Top Five', resulting in several redundant ones. A common trap in game mixing is to plan for too much. Games can be so complex that you could aim at making everything extremely curated, ending up with too many snapshots in your design. While you want to make your focal sounds change dynamically based on the scene and the action you want to highlight, modifying the soundscape too much or too dramatically in a systemic way could also result in providing too much information for the players, changing the focus too often. Less is more is often the right approach when using rule-based snapshots for systemic mixing.

As with any paper design, keep in mind that nothing is really set in stone. Try to stay agile. You cannot possibly anticipate all possible scenarios and edge cases on paper, and it is very likely that you will have to add mix snapshots along the way, or that you will have to go back and iterate on your preliminary systemic design.

'On my previous projects, we used mix snapshots attached to various game states to help emphasize or de-emphasize various sub-mix volumes depending on the context. Those changes were subtle and quick so that they were not obvious to the player. This technique significantly improved the clarity of the mix'. (Rob Krekel)

After the design phase, when implementing and testing new snapshots in your game, start by adjusting your focal point and most important sound categories first. It's all about getting the focus where you want, and evaluating what you can still hear or not from other sound types. Things will come more naturally then to decide what you still want to hear or not from other sound categories. A lot of ideas and try-outs also need to come organically while working on the game mix. You will realize more easily if other sounds are essential in the context of the mix or if they are just adding unnecessary 'noise'. If the latter, it might be time to remove entire sub-categories of sounds on a snapshot basis. Another important point during the snapshot implementation phase is to not tackle all snapshots at the same time. This is especially true for systemic rule-based snapshots. As much as

possible, try to implement them one by one, take the time to test your implementation, and evaluate the mix changes thoroughly. Make sure everything is solid technically and aesthetically before moving on. Think of it as a sequential iterative process. Start by working on the more important snapshots. For example if you are working on an open-world third-person action-adventure game with stealth mechanics, then start by implementing and mixing your exploration and combat snapshots. Then, once those two feel in control, add 'stealth' (or 'infiltration') which should ultimately feel like an in-between snapshot. This 'stealth' state will allow you to smoothly transition between what are likely two radically different sounding mixes.

Similarly, try to have your systemic rule-based snapshots sounding great before implementing one-off snapshots (for example to change your mix for different narrative beats). Rule-based snapshots are usually part of your macro mixing process, while one-off curated snapshots can usually be considered more polish work as part of your micro mixing phases. Rule-based snapshots are often made of subtle changes, which can get you a long way on your path to improving readability and clarity in a game. 'One-off' snapshots used during micro mixing can be more dramatic, with the aim of triggering a strong emotional response from the listener.

Cull on audio emitter levels to keep control over your mix

When adopting the rule of 2.5 mentioned previously or working with snapshots, and considering any other possible challenges that might arise because of the complexity and singularity of the game you are mixing, working on a strategy to spawn or not audio emitters can be a robust solution to keep control over your mix. There is a lot that can be done with voice limiting and run-time signal modulation, but working on the emitter level allows for creating your own spawning rules and budgets. There are many layers of complexity you could build with a good emitter management system. For example, you could change your entire priority and spawning rules based on the active mix snapshots. Getting control over your emitters spawning conditions is great, but it can also comes at the cost of being heavy in development resources and time as you will likely need audio programming support to reach your mixing goals.

Sound prioritization

> 'To improve clarity in the most busy gameplay scenarios, it's important to remove sounds that are unimportant to the player. Preventing sounds from playing has the added benefit of saving voices and CPU overhead'. (Rob Krekel)

Besides providing extra control and de-cluttering your mix at source, the fact that you won't have to cull voices or mute signals if you don't spawn the associated emitters in the first place allows you to both save precious CPU calculations (as every instance of emitter and associated voices occurring in a game impact the amount of CPU being used), as well as improve efficiency when it comes to profiling. You're not spawning emitters and playing signals that don't need to be heard in context, so those emitters and the sound voices associated with them won't show visually in your profiling tools.

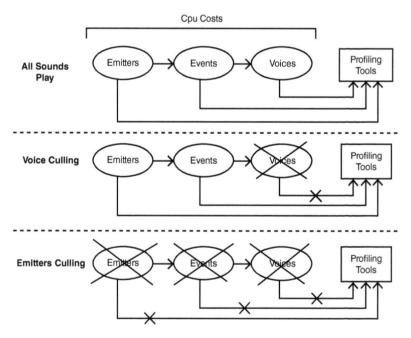

Figure 5.2 Culling emitters versus culling voices

'Ideally we want to cull content before it even gets into the mix (before the trigger). This helps the mix tremendously even though it's not happening in the mixer'. (Loic Couthier)

It's good to keep in mind that the spawning rules you would create for one game might be vastly different for another. Even if you decide to adopt the rule of 2.5 for any projects you're working on, the conditions and variables that can change your mix based on that rule would depend on the aesthetic, the play-style, and the type of game you are making.

'Culling is the first tool in the mixing toolbox. We remove material for the sake of clarity, with the intent being to better present and to preserve information. This process is also used to focus on the narrative red thread and the embedded, emotional sound'. (Ben Minto)

When working with emitter management, a first base rule is to not spawn any audio emitters that are outside of the listening reach. If the emitter is too far away to be heard, don't spawn it. This will have no impact on your mix, but will do on your CPU and profiling. Then, you could create as many rules as you wish. You could limit the number of an emitter type. For example, in combat scenarios, you could decide to only play a maximum of five enemy weapons at any one time. Those could be the most threatening five. Then within those five, only two will be heard clearly in the mix, and the other three will take on a 'world building' function, using real-time modulation in your audio engine (i.e., side-chaining, ducking, filtering, etc.). You could also decide to apply a first layer of the rule of 2.5 directly on every emitter's family (i.e., 'enemy weapons', 'enemy Foley', 'enemy vehicles', etc.). Having that layer of granularity on the emitter level provides endless opportunities for the mix, deciding at source what information will be heard, and which will never play on a context basis. It also allows for limiting the budget per audio emitter entity. A good technique can sometimes be to categorize your audio emitters in the same way you've been categorizing your sounds (for example, through your bus structure).

HDR is handy to reduce manual labor and for immediate results on busy gameplay instances

HDR is a relatively simple technique on paper from an end-user perspective (the mixing person). It can be an efficient way to prioritize sounds depending on the type of game you're making. Simply put, HDR is an automatic mixing technique that uses prioritization of signal based on one main rule: the loudest sounds always play. HDR prioritizes louder sounds in perceived loudness at listener position, and calibrates the output signal to those loudest sounds through a HDR window while automatically culling sounds that are outside of that window. It provides the feeling of making things feel louder than they really are. This technique can be very efficient for games with a low-predictability soundscape (i.e., competitive games, multiplayer games, action-driven shooters, etc.) providing almost immediate results. It also often reduces significantly the manual labor: if your contents mastering rules and implementation are well made (and build at source around the idea of using HDR), the mix should sound quite good right away with HDR.

> 'In *Battlefield*, HDR works perfectly as louder generally equates to "kills you faster" or "more important". The goal with those titles was to allow us to encode as much information into each cue, but then mix in such a way that that information could be readily decoded by a player so that they could make better informed decisions and hence play better. Lucid mixing to enable player agency. Play fewer sounds, but make sure you still play the relevant "right" ones'. (Ben Minto)

This single rule based on dynamic range might not be sufficient for all scenarios offered in your game though. Or it might not be the right approach depending on the game type you're working on. HDR can also come at the cost of losing creative control and flexibility in your mix, especially if you need more complex rules and conditions to decide what needs to be in focus in your mix, and what can go away. In that case, you could think of adopting HDR on top of other rule-based snapshots, sidechains, or voice and emitter management systems, as it can save time and get rapid results in de-cluttering your mix for dense gameplay scenarios. When using HDR, it is often important that on top of the calculated loudness you have the flexibility to define and specify a priority scheme between your different sound categories (i.e., critical versus non-critical sounds, or a low-medium-high importance scale, or sounds playing at all

times independent of HDR window scenarios) to keep enough control over your mix.

Use side-chaining to provide extra preciseness in your mix

Side-chaining is a real-time mixing technique often used in games to control audio focus, cleaning the mix with a natural sounding result. Side-chaining can be extremely precise and offers a lot of custom options in your mix to achieve clarity. It monitors the level of an audio signal and uses it to manipulate others with a great level of control with volume automations, boosting or carving EQ bands, enhancing or reducing the dynamic, amplifying or reducing distortion, changing the effects balance (reverbs, delays), etc. The aesthetic possibilities are numerous. For example, in an RPG safe zone with friendly NPCs all around and a quest giver, you might have voice 'walla' as well as idle ambient voice barks playing randomly around the player while an in-world animated sequence can be triggered when the player interacts with the quest giver. For such a game scenario to feel and sound good, understanding the story should be effortless, so you always want to make sure the dialogues' intelligibility is perfect. In the eventuality that you want to keep other ambient voices playing during the narrative scene, you could then set up a side-chain that will monitor your quest giver narrative VO bus (considered critical information), side-chaining the ambient systemic VO bus (non-critical). That side-chain, on top of a few dBs of volume reduction, could be used to set up a high-shelf filter lowering in the voice frequency spectrum (between 2K and 5K), and perhaps make them feel even more ambient by making them more diffuse in the mix (i.e., changing the pre-post fader reverb sends for those voices; and/or reducing the accuracy of their 3D spatialization), leaving space for the narrative dialogues.

When using side-chaining, remember to design and follow a priority scheme amongst objects of different sound categories, and then deep dive between sound types within a category. The previously explained concept of critical and non-critical sound categorization will be handy when dealing with side-chaining. In most cases you would want to be metering the signal from critical sounds and processing the signal of non-critical sounds.

> 'I like to use dynamic EQ by side-chaining one bus to another and carving out the frequencies in one bus based on the input of the other to bring things in focus and have an overall natural sounding mix'. (Brad Meyer)

The main inconvenience of using side-chaining is that it can be costly CPU-wise if using the technique a lot. Adding preciseness with a high level of control can also mean more manual labor to implement, maintain, and iterate on your mix. It's also good to be cautious when using side-chaining to not make your mix sounds too artificial. Remember to A/B test your mix when implementing and using side-chains. Subtle signal modulation and working with both frequency spectrum and volume (or dynamic) usually sound more natural than dramatic modulations on volume or dynamic alone.

> 'I find that using side-chaining tends not to work well if you are aiming for a cinematic aesthetic'. (Rob Krekel)

While side-chaining can be efficient and a natural sounding technique if used meticulously, it can also sometimes be inappropriate to use if you're aiming for a 'cinematic' feel in your game mix. The reason being that side-chaining is not a technique that is used a lot in film mixing. In a film or in a very linear game, you get more control over which sounds need to play and which don't. This should be considered at source when designing, writing, editing, or directing the story, so it's easier to make sure you have space for important elements of the mix by removing or processing differently less-critical sounds or sound categories.

Use ducking only when it sounds natural

Ducking can be considered a reduced and less precise version of side-chaining. It only modulates the volume based on the fact that a signal is detected, generally on a bus, instead of monitoring the amplitude of the signal and modulating the target signal based on that amplitude. It can still be an efficient way to have sound categories more prominent in your mix for specific type of games, features, or for lower-end target platforms as it comes at a cheaper CPU cost.

> 'To create further space in the mix, I like to use side-chaining and voice management. Ducking can often be quite harsh, as you can hear it kicking in and out, so I would reserve it for times when I've tried everything else'. (Adele Cutting)

Because ducking is not taking into account the signal amplitude or the loudness when modulating other elements of the mix, it can be harder to make things sound natural, especially when it comes to 3D sounds that would be attenuated and filtered over distance. But ducking can be an appropriate technique for 2D sounds that play consistently at the same level. An efficient technique to avoid an artificial sounding mix when using ducking on 2D sounds is to use other sounds to cover the ducking transitions. For example, in a first-person shooter you could decide that you want the player weapon sounds to duck other elements of the soundscape (i.e., in the eventuality that gunplay and first-person immersion are your focus). To make the player weapons sound natural while ducking other sound categories, you could split the transient part of the signal from the rest of the weapons' signals, and send it to a specific bus, while the body and the tails of the weapons' fire would be sent to another weapon sub-bus. That transient sub-bus would then duck the non-critical elements of the mix, while the sub-bus containing the body and the tails would be used to cover the ducking system transitions. Ultimately, if you still don't get what you're aiming for in terms of clarity or control, then consider moving on with other techniques.

Transitions are always key for a smooth experience

In audio, getting transitions sounding right is key: between gameplay instances and cutscenes, between different locations in the game, between different scenes, but also when prioritizing your sounds. You could aim aesthetically for different types of transitions: some would be quite slow with the aim of building anticipation, while others would be sharp to add a strong sense of impact or urgency in your mix. It all depends on the type of game you're making and the creative direction your mix is serving. Ultimately, the mix of a game should be transparent and you don't want the players to notice those changes. That means that transitions should sound convincing in the context of the game. Always keep in mind that it is more important that the transitions serve the game mechanics than your personal taste.

> 'Sometimes helping the players might be contradictory to the instinct of making something sound aesthetically nice. A brutal transition might sound a bit rough but help a player react faster. If the nicer transition goes against the interest of the players, you may have to make the informed decision to support the player's performance'. (Loic Couthier)

When using real-time signal modulation techniques, one of the goals beyond focus is generally to deliver a transparent sounding mix. The same is true when dealing with snapshot mixing. The main components of having great sounding snapshots transitions are both the transition time and their triggering conditions. It is not uncommon to also end up with snapshots exclusively created for transition purposes between the ones that sound too dramatically different to your taste, adopting a 'major' and 'minor' snapshots approach. 'Major' snapshots would be made for the main gameplay or narrative instances, while 'minor' ones will be used for transition phases. For example, if you work on a third-person shooter with long exploration phases and intense combat arenas, but where stealth is not core to the design, you might need something to transition smoothly between 'exploration' and 'combat' instances. Those two would be considered 'major' snapshots. A resulting 'minor' snapshot could be 'pre-combat', detecting enemy AI within a range around the player to allow the buildup of anticipation for the possible combat instance to come, smoothly adjusting the mix of the different sound categories accordingly. The same could be applied for 'post-combat'.

> 'I like to make my mixes as transparent as possible and always try to find techniques to avoid apparent sounding modulations'. (Brad Meyer)

When it comes to real-time modulation techniques, transitions like fade times, attack and release times, as well as making good use of other sounds to cover the signal transitioning are ways to avoid any unwanted pumping effects ultimately resulting in an unnatural sounding mix.

Chapter 6

Frequency spectrum

Corrections are on the contents level

The most common way to work with equalizations is to use them as a corrective tool, identifying and cleaning any unwanted frequency contents. The idea is simple: you need to cut off the unnecessary frequencies to avoid masking, freeing up space that can be useful to other sounds. Removing unwanted frequencies will also help to keep a good dynamic without reducing dramatically the loudness of your mix. A first step is generally done offline on the content level during or prior to assets mastering, while a second step can sometimes be done in the engine or middleware once you have a better feel for your sounds in context (with appropriate visual cues, gameplay feedback, and other elements of the soundscape playing together).

To shape your sounds individually, remove frequencies that are not relevant because you cannot hear them in the contents. Start with the extreme lows and highs as they will mask other sounds, and then move on to carving frequencies that you believe don't belong in those contents. While equalizing your contents individually is necessary, it can also lead to bad mix decisions, as you are working in isolation, outside the game context. Context is everything to build engagement, so it is generally good to do a 'safe' correction first pass on individual contents, and then do a second pass to test and work further on adjusting your contents' spectrum after listening to them in the game context.

> 'Working on EQ in-engine provides greater flexibility and allows recycling content for multiple purposes'. (Brad Meyer)

DOI: 10.4324/9781003351146-7

Some audio engines allow you to 'bake' or 'render' your inserts or effects. Being able to do that work in-engine is great for flexibility, ensuring your mix is always balanced and that every element finds its space. Having access to a 'render' option is important to avoid unnecessary CPU calculations, as those corrective equalizations don't need to modulate signals at run-time. If you don't have access to those rendering options, you could consider going back to your assets mastering chain to make the necessary additional adjustments and re-export again.

> 'I prefer to bake equalization into the asset, because EQs outside the game engine are usually of a better quality. EQ use at run-time is an extra CPU cost'. (Ben Minto)

Some people like to do most of the work outside their engine independent of the rendering options available, because using commercial plugins in a digital audio workstation tends to sound better. It can also offer more creative possibilities, by using different plugin brands and models to slightly modify the 'color' of the sounds. Some other people prefer to do the work in-engine and 'render' the corrective equalization to get a better feel for the sounds in context (and save some production time).

Further spectral balance adjustment between sound categories might be necessary too

While corrections are made on the contents level, once every element of the mix has been carved to ensure all contents are as clean and precise as possible, you might still need to adjust your spectral balance on the bus level to make sure every sound category finds its space. Working on the frequency spectrum on the sound category level can be an essential step in your mixing process to add more clarity and focus in your soundscape once you have your base priority scheme and volume balance under control. Spectral balance adjustments on higher categories of sounds is all about making sure all sound types find their space in the frequency spectrum even in the worst possible scenarios. For example, when a lot of similar sounds from a frequency perspective are playing at the same time. In that case, it is not uncommon that equalization would be mostly about making compromises for the sake of the holistic listening experience.

'When all elements of the mix are in, I listen to the frequency spectrum as a whole to evaluate if there are too many mids, too much low-end. Then I try to understand what is contributing to this. Instead of making things that needs to be heard louder, a better mixing approach is to work on removing assets, using EQs, or framing the moment'. (Adele Cutting)

You can then adjust the spectrum by category of sounds and decide what needs to use a large space in the spectrum, or what needs to use a narrower space. You could also modify those EQs at run-time, depending on the game scenarios, in the eventuality that you would want to make things sounds more or less rich tonally based on the active mix snapshot. It then becomes all about anticipating the different scenarios of your game and leaving the space for your focal points or your 'Top Five' sound categories on a per-snapshot basis. Making sure the frequency spectrum is adjusted at run-time depending on what's going on in the game allows you to be more gentle on live signal modulation (i.e., side-chaining, HDR, ducking) by ensuring everything finds its space in the mix first and foremost, which can result in a more natural sounding mix.

Those adjustment will also allow you to be gentler on your game mastering, as you would get your overall soundscape under control frequency-wise before reaching the master.

Consider your game audio end-point(s) when working with frequencies

The player's playback device(s) are the end-point(s) of your mix. It is important to consider the most common (or expected) end-point(s) when working on your equalizations. Games are complex because we often cannot fully anticipate what playback device(s) the players will use to play the game: it can vary greatly between headphones, stereo speakers, surround speakers, sound bars, or built-in speakers (i.e., mobile phone speakers, TV speakers, handheld console speakers, etc.). Think about your target audience: how will most of your players play, listen, and perceive your mix? If you are working on a mobile title and more than 50% of your players are expected to listen to your mix on their phone's built-in speakers, then your mix needs to sound good for this end-point first and foremost. This ultimately means that

you should probably not make the same spectral adjustments for that mobile title as you would for a console or PC game. There are two main trends here: some people aim at making the best sounding game on the best possible end-point of a given platform, so those people would aim at the best quality experience on headphones for that mobile title for example. Others prefer to make their games sound great on the most expected end-point (so the mobile's built-in speakers in this example) while still getting the mix balanced correctly for other users. Both approaches are valid. You could argue that those adjustments could be made during the mastering pass directly, but keep in mind that the less processing you have to do on your master generally the better. Working on your master impacts the entire mix and does not only target specific audio contents or sound categories. Doing such adjustments on the master could harm your mix on specific speaker configurations. It is usually good to do more work upstream in your mix processing chain for better sounding results across all your possible end-points. You could do it either on your contents sculpting or on your busses (targeting sound categories), or both. If you decide to do the work mostly on the bus level, you could equalize your sound categories differently based on the different available end-points as a possible first upstream step for mastering. Then you could provide options in your audio settings menu for players to select their playback devices (i.e., mobile speakers, headphones, etc.), activating or bypassing different equalizations on the bus level.

Subtractive equalizations sound more natural

Creative mixing in games is often a more subtractive process than an additive one. When correcting your sounds, equalizing is like sculpting: you want to remove the unnecessary bits without necessarily adding anything. It's all about tonal shaping, removing things that are redundant instead of trying to add tonal elements that do not exist at source. If you feel you have to add frequencies, it often means the sound sources are not rich enough so you should probably go back to the design phase to rework those contents. Cutting frequencies is often a more efficient way of working with equalizations as it generally ends up sounding more natural.

If you are not sure what frequencies to remove when sculpting the spectrum of a sound, start by boosting the gain of a frequency with a

narrow width. Move the frequency slowly around until you find something that sounds wrong. Then reduce the gain on any unpleasant frequencies until it sounds good. A good way to ensure you've carved your sound entirely is to do that on the entirety of the spectrum, starting with the lows and ending with the highs.

Beware of not changing the character of your sounds

While working on correcting and sculpting your sounds, try to avoid making things sounds over processed. Beware of changing the character of the sounds with equalizations, except of course if this is a creative choice you're making while mixing. It can be better to keep some imperfections instead of having something sounding too artificial. The beauty and tastiness of an artistic piece can also come from its imperfections, especially when these make other parts of the piece stand out even more by contrast. When removing or adding too much with EQs, you are changing the tonal shape of a sound, which can result in having a signal of a lower quality. When in doubt, A/B test and listen to your processed and unprocessed signals at the same loudness level to evaluate if you've gone too far with your processing. When you need a fresh perspective on things, collaboration becomes crucial; ask others for feedback and try to bring in the person(s) who worked on those audio contents to have a listen. It can sometimes open up an interesting discussion about the design intentions if it turns out that the sound has been changed too much during the mix. There are always a good balance and compromises to be found between cleaning the mix, adjusting the frequency spectrum, and staying true to the original design intentions.

The energy and the sense of scale are in the lows

Low frequencies produce more energy than high frequencies, which means that the power of your mix is generally in the low-end. However, low frequencies can also reduce the loudness of your mix, so make sure to keep things under control and try to find the right balance between energy and loudness. Working on the low-end is often where you want to start when dealing with equalizations.

'I often start my equalization work with the low-end. Because while cutting or designing in a small room, it's usually the low-end that is difficult to gauge. Only once we hit a large room do certain frequencies become more

> apparent and problematic. Or I'll find now that they are lacking since often they get exaggerated in a small room'. (Tim Nielsen)

Frequencies between 180 and 500Hz have a tendency to sound boxy and add muddiness in the mix. Taking a bit off in that range will naturally free up the low-end, making your mix feel cleaner. It's important to deal with those frequencies with care, as removing too much could make your mix sound hollow. A few specific sounds might also find their character in that range, so you need to be meticulous and precise here. Then, cutting any unwanted sub and low frequencies will create more headroom in your mix. It will allow you to produce a mix that generally feels louder, but also clear space for other sounds that should occupy this lower spectrum. There are different mixing philosophies here, but removing unnecessary frequencies below 60Hz can be an efficient approach to both bring power to your mix and leave space for curated low-frequency effects. It will allow you to be in a better space to control when and how you should play low frequency effects (LFE) based on specific objects, actions, or narrative scenarios in your game.

The low-end is also essential to sell the sense of scale of different objects in a game. In the audio design phase people usually try to make every sound as rich as possible. When mixing, making sure that all elements of your mix are not equally powerful in the low-end will allow you to deliver more contrasts in your soundscape. For example, make sure that you don't make a pistol, an assault rifle, a shotgun, or an explosion feel equally powerful in the low-end. The lows are also an important part of the frequency spectrum to play with contrast in a mix, adding impact, drama, tension, etc. Allow yourself to craft moments with very little low-end followed by sequences with powerful lows to enhance the feeling of power in your mix, triggering a stronger emotional response.

The noisy range is around 2KHz

Frequencies around 2KHz don't usually bring much to the mix except noise. This picky frequency range is where you might want to do some clean-up. Working on this will usually help to make the mix feel both more powerful and bright.

The clarity, sharpness, and proximity feel are in the highs

The high-end can add preciseness and sharpness in your mix. How much of this you want in your mix is a matter of taste and style. If you've done a good job balancing your spectrum on the low and mid ranges, you should not have to do much here. Everything you've already done should have naturally brought clarity to your mix.

Working on the high-end frequencies can allow for pushing things forward or backwards in the mix. You can reduce the high-end to put things over distance, or boost it a bit to highlight sounds at close distance, making them pop up more in your mix than others. You can also use that frequency range to highlight sounds that are points of interest for the player at close distance. For example, if you have idle sounds on objects that players interact with in your game, and you want to make them stand out to provide the necessary gameplay feedback, you could think of boosting the high-end for those sound elements when nearby or when the object is in focus toward the mid-center of the FOV. You could also work the other way around, gently reducing the high-end of other sounds with a subtractive high shelf to make the most important gameplay-related sounds more clear and crisp, creating an elegant contrast in your mix. When deciding to boost frequencies in the high-end, beware of making things sound too piercing or fatiguing.

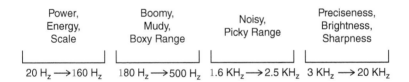

Figure 6.1 EQ cheat sheet

Talking to: Tim Nielsen, Supervising Sound Editor, Sound Designer and Re-Recording Mixer

Tim Nielsen is a Supervising Sound Editor, Sound Designer, and Re-Recording Mixer working in film, with most of his career having been at Skywalker Sound in California. Tim is an enthusiastic sound effects recordist who founded a Universal Category System to help the industry catalog libraries. Tim also often helps crowd-sourced recording projects to raise money for charity.

Mixing in the motion picture industry can be quite intense, as you usually have a few weeks to mix a full movie. How do you keep your energy and morale as high as possible to ensure delivery of a great mix?

The most important thing is being prepared as much as possible before the mix happens. The mixing stage is expensive, so as a supervisor, I want to make sure that all of the material is covered before we hit the stage. Often this may mean removing and muting things as well, trying to streamline what we bring to the stage, as it's just as easy to overcut as to undercut. The mixing stage ideally is about creative decisions and not just problem solving. I often will pre-pan most of the material prior to taking it to the stage. I'll also have done quite a decent pass on the volume graphs so that even by the time we hit the mix stage, the 'shape' of our project should already be somewhat defined.

Then once in the mix process, it's important to take small breaks whenever possible. If mixing as a team, I'll let my colleague have an hour and I'll try to at least step out of the room for 10 to 15 minutes and encourage them to do the same.

It's also important to manage client expectations, and often this entails explaining to them when they should be paying attention, and honestly when NOT to. There may be some time when I just have to make a pass for myself, and it will be frustrating for them AND me to have them making judgments before I'm ready to actually present the material. So I may, as gently as possible, kick the director out of the room as well!

And then make jokes. Find things to laugh about. Even in the tensest moments of the most tense films, hopefully there is also laughter.

What's your overall process when it comes to planning your mix?

It's all about pacing and prioritizing. Every day I'll map out ideally how far we should get through the project. Maybe we all agree, today we want to be through the first seven minutes of the film. We build out a roadmap spreading the workload across the available days and try and come up with a game plan. This is crucial. We will often fall behind this, especially at the beginning. But we

will need to start knowing soon if overtime will be required, if we need to start working late on some evenings. It's also good to have this mapped out with our starting conditions. Meaning when the client comes and says 'oh we're changing this reel, putting in a whole new scene' we need to be able to say 'Well look, this WAS our schedule, but it was assumed that you wouldn't be doing that, so now it will have these repercussions'.

And it's important to work in broader strokes to begin with and then more refined passes as you go along. Getting bogged down at the beginning with very slow-paced detailed work is the path to disaster, when you have spent half your mix time on the first tenth of the movie. I've seen this happen numerous times. That also has to be explained to the client, and we'll often have to say, 'Look we really can't get bogged down on this now, let's get to the end and we'll circle back'. Even if sometimes we can't, every mix is about prioritizing and compromise. As someone once noted, mixes are never finished, they are simply at some point abandoned.

What are your first steps when starting a mix?
I'll usually have seen the movie so many times by this point that I can just start in. We are almost always mixing in passes, called 'pre-dubbing'.

So first the backgrounds, and I'll always start with the simplest layers: the airs and room tones. Then come additional details, then the hard effects, and finally the Foley. Once all of these are prepared we can start the final mix. The dialog mixer will have also pre-mixed the dialog separately and then together we'll bring in the music, have all the elements together.

Often the dialog mixer will lead, setting the proper level of the dialog for me to work around and against. But it's constant back and forth and sometimes mixing at the same time. While they may be rolling the bus and working on dialog, I'm also sneaking in small moves that won't distract them. Once we have that pass ready, our own first pass, we'll present that to the clients, and then it's all about notes, fix passes, notes, fix passes.

Is it quite common from your experience to remove or add things from the sound edit when mixing?
The mix is ALWAYS changing, and I've never seen a mix where the sound edit didn't change during it. Often it changes very much. There are numerous reasons for this.

Firstly, often new visual effects require changes, additions, and modifications to both sound effects and sound design. This is often the first time we've put the music up against the final effects as well, and there may be conflicts that have to be sorted. That said the music itself will often change too, we may recut a cue, remove a cue, and repurpose a cue to another spot.

And lastly, it's the first time the director and other clients will have heard everything together and often there are simply things that don't work.

We always have at least one effects editor on the stage, with an off-line ProTools system that will be paying attention to the dialog in the room, which the director can turn to and ask for something additional. There will also be someone to handle music editing, and dialog editing as well. We will also know the film well so we can often move quite quickly. But it's not uncommon for there to be 32 to 64 additional 'Fix Tracks' added into the final mix of a large Hollywood film.

Can you explain what is a common reverb configuration when you're mixing movies?
I've seen this done many ways. Mostly what I see done, and how I approach it, is I usually have four or five 'stock' reverbs in my template. And I'll have a set each of those for ambiences, for effects, and for Foley. Usually they are configured roughly as a very small interior space, a medium sized interior space, a pretty large interior space, and then an exterior 'slappy' space of some kind. The fifth reverb is usually a floating one, that I can automate changes to in real-time during the mix and often ends up being a very long and very lush one used in very stylized moments of the film.

Since automating these plugins is quite easy it'll also be common that I may be changing the parameters of the 'large' reverb at various times in the film. If so I'll always save a preset for myself to be able to recall for example what I used for a particular space in another part of the movie.

When working with surround, do you keep the center channel exclusively for narrative voices, or do you like to make more creative use of it?
I don't want the center channel to be entirely clear of FX or backgrounds, no. Most hard effects that would be linked to a character on-screen would be coming out of the center channel. It's important for believability. If I were to try and spread the footsteps to the L and R channel to somehow clear the center channel it would sound bad. That said, in other times for sure we have to be aware of the dialog in the center channel and often this would lead us to move something 'off-screen' if it's not something directly 'on-screen'. So in a busy traffic scene, maybe I move some of the traffic into the surrounds to help clear out the center channel to help with intelligibility.

When mastering a film, you often have to output different speaker configurations for your mix. What's your approach to ensure a consistent mix across different speaker configurations?
In film (not in TV) the mastering pass is really just about the creation of the various deliverables. For us, once we hit that phase of the mix, 100% of the creative decisions should be done, we should no longer be doing anything volume related. But that's in film, where there are no levels being measured, and no rules at all. We're simply mixing to our ear. Now we may be doing a simple 'true peak limiting' pass just to avoid peaks, but often a theatrical film mix will be peaking all over the place to be honest. As long as it sounds OK, it is OK, tends to be the motto.

Now in streaming or television, which is even more restrictive, the master pass may well be a 'compliance' pass as well. But hopefully even during the mix we've been monitoring those levels and aware of them. But yes in a streaming mastering pass we are bringing the project into spec and making sure it won't get rejected.

When it comes to exporting different versions of the mix based on speaker configurations, the most important is really just to carefully prepare how we intend to fold down each subsequent version. The stereo is the only one that is usually problematic as it's the first pass where the center channel disappears, and so it will sound very different. The 7.12, the 7.1, the 5.1 can all sound very close to each other and are rarely problematic. First we decide if the tops go to the side or to the back. Then from 7.1 to 5.1, do the sides go to the back or get split between front and back. These are just decisions based on the taste of the mixers. We'll then listen through in that format and if we want to stop, we can tune as we go along and make a different decision based on each moment where something needs to move to a new speaker.

The stereo is just a compromise. It'll never sound as good as any of the surround versions, and usually then the discussions while making the stereo are just that in losing the center channel, we really need to keep the dialog intelligible. So often the stereo raises the dialog and lowers everything else slightly.

Any last words of advice you would like to share?
I'll leave you with my favorite quote about the type of creative work that we do, and this is from the author of *The Little Prince*. He said, 'Perfection is achieved, not when there is nothing more to add, but when there is nothing more to take away'. We often think of everything we do as an additive process. Add the dialog. Add the backgrounds. Add the music. But a creative edit, a creative mix, should equally be about refinement. If something can be removed and you aren't obviously aware of it going away, then it shouldn't have been there in the beginning!

Chapter 7

Dynamic

Favor leveling instead of compression to control volume

Compression can feel powerful like a powerful tool to better control your levels. However it's good to keep in mind that it also brings up background noises, particularly on live-recorded audio assets (i.e., Foley, musical instruments, ambiance, voices, etc.). While those individual elements might sound acceptable with a bit of compression separately, the noise floor of your overall mix will be brought up when a lot of compressed contents are playing simultaneously in your game. To keep your levels under control it often works better to focus on getting your playback volume right during the content production phase instead of relying on compression (whether for audio contents mastering or in engine). Spending the necessary time and effort to ensure consistent contents mastering is key to avoid adding too much compression. The less compression you use for controlling your levels, the more dynamic and natural your mix will sound. You could then keep dynamic work for more creative uses.

> 'When working with SFX or music, I always think about how it'll generally play in relation to other sounds in terms of dynamics, and rather than normalize it I'll keep it at the level that I imagine it'll most commonly be played back in the game. In cases where that could vary a lot I prefer to have different versions with different intensities'. (Martin Stig Andersen)

Compression could of course be used with a control role in mind, on the bus level to control peaks, to run some subtle level matching, or to reduce the dynamic of a sound category to get better control between quiet and loud moments. If you feel like you do need those compressors to help with getting your mix under control, try to be

gentle and keep dynamic reduction to a minimum. Once you've balanced your levels, some elements of the mix might still feel too dynamic. If some sounds or sound categories peak or disappear in the mix, it means that dynamic balancing is necessary.

> 'I like to use compression only when needed. There is nothing worse than feeling like you're playing a game of Whack-A-Mole with a series of quiet, then loud, then quiet sound effects. Again though, this is why I'll hopefully have solved much of that before the mix'. (Tim Nielsen)

Compression can be efficient to 'glue' things together

When you have a lot of sounds layered within a sound category, possibly made by different people at different moments in time through your game development cycle, and you cannot manage to make them sound coherent together using only volume and equalization in your mix, using a compressor could be the magic move that glues things together making it feel like one entity. For example, if working on a third-person game, your player character Foley sounds (i.e., footsteps, clothes, armor, weapon rattles, etc.) might have been created and recorded by different people, in different recording environments, at different times. Using a gentle compression on your player character Foley parent bus might help to tighten things up a bit. The idea is to make things sound natural, avoiding the classical compressor feeling that could make things lifeless. To verify you have not taken it too far, make sure to A/B test your work when using this method. Also take the time to check the bus compressor frequently, watching for the gain reduction not to exceed -1dB.

> 'I like to use compression a little while mixing, especially on elements built from layers to help with the overall gluing together at the patch/sound creation level'. (Ben Minto)

Parallel compression can be used to add impact and aggressiveness in your mix

Parallel compression is an efficient technique to make things sound bigger and more impactful in a mix. If you feel you need to push

some sound layers or sound categories to the forefront of the mix while making them punchier, you could simply make an exact copy of that signal and squash it to the maximum using a compressor. The process is straightforward: create a 'parallel compression' auxiliary bus, and insert a compressor on that bus with extreme settings: a fast attack (to make sure the transients are caught in that signal), a high ratio, a medium to long release (to hold the compression), and relatively low threshold. Those exaggerated settings will allow for high gain reduction with heavy compression, resulting in not having any dynamic left on the compressed signal. Adding a pre-compression equalization could ensure the compressor is doing its work only on the frequency range you want to use with that parallel compression technique. Depending on the aesthetic you are aiming for, it could be judicious to also use an equalization post-compression to add presence and shape tonally to the compressed signal. It generally entails cutting the low and high-end, and removing a bit around 2–3KHz, which is the pain frequency that could really damage your effect balance with such a compressed signal. Then, send the signal you want to make more aggressive in your mix to that parallel compression bus. Finally, adjust the send levels to have a nice blend between the original signal and the heavily compressed signal.

Parallel compression is typically the kind of thing that you want to feel, so you would miss it were it not there, but do not want to hear distinctively in a mix. Be cautious to not push things too much. It's all about finding the sweet spot. This sound technique from the music industry is quite efficient for anything that you want to cut through in your mix. It can be used offline on contents, or at run-time on sound categories depending on your tools and your needs. When used at run-time, it can be activated or by-passed based on the current active snapshot, to make a mix more aggressive for example on weapons when in combat, creating further contrast on the same signals with roaming gameplay phases of a game.

You can use (tonal) compression to make a sound or sound category feel 'bigger'

While usually not extensively used in game, you can also of course use compressors instinctively to reduce dynamic. You could use compression to alter the character or the 'color' of a sound, providing a better feel for some tonal or harmonic nuances, to give more 'body' to a sound or a sound category, or for creating a more dramatic sonic

difference between focal and non-focal audio categories within a given snapshot. Even in a well-balanced mix, tonal compression can be effective to make sounds feel 'punchier', or 'thicker'. Part of that is about using saturation, the kind that enhances some frequencies to make a sound or category of sounds feel more 'excited'. While this would mostly be done offline on contents, it can also efficiently be used on sound categories on a snapshot basis (i.e., using contents' switching at run-time instead of processing signal at run-time). This way, you could change the thickness of sound categories, especially for your 'Top Five', to make those sounds feel bigger or more prominent in your mix. Here again, don't push it too much. Getting it to sound right and natural is all about subtle changes and creating slight contrasts between sounds, or between sound categories, in relation to one another in different game scenarios.

Multi-step compression usually sounds more natural

If you are aiming at extreme compression settings, try to compress in series using multiple compressors instead of one plug-in with extreme settings. This will allow you to use gentler settings on each compressor, putting less stress on the plugins, resulting in a more natural sounding mix. It's all about splitting the workload. For example, if you are looking at a 12dB gain reduction, then use two compressors each pushing 6dB gain reduction, as the sum will provide you with the desired result without having to push as much on one compressor which would start to sound bad, or coloring your sounds too much. If that's not enough, then use four compressors each with a 3dB gain reduction. Another good reason for using compressors in different stages is that it helps you to focus on what you want to get from every single compression step. You could then aim to get different characteristics and focus for the different compressors on top of getting a higher gain reduction that sounds more natural. You could use different plugins with different sonic characteristics to aim for different types of compression: for example using one compressor to control your peaks, another to 'color' the sounds, or to modify the characteristics of a sound category, and another to glue things together, etc.

Talking to: Ben Minto, Company Director and Supervising Sound Designer

Ben Minto is one of the four Directors who run and own the Sweet Justice Sound Group and who previously worked at EA DICE for almost 15 years, and EA for over 21 years. Ben worked on many *Battlefields*, *Battlefronts*, *Burnouts*, and a *Black*, as well as many other non B titles over his career.

When starting a new game project, how do you like to plan your mixing?

As part of the overall audio direction, the 'mix' is a key pillar. There should be preproduction work completed that defines what the high-level goals are for the mix, with plenty of reference, maybe from previous titles, other games and even other media (film, TV, YouTube etc.), as well as anti-visions – i.e., what a 'bad' mix would be for your title, maybe too much compression, compressed dynamic range, not enough culling of sounds, fights between dialogue and ambiences, etc.

During preproduction a linear asset should be produced that demonstrates the mix qualities wished for in the final product – a target. As part of this work a 'golden' example of at least one of each main asset types will be produced – a weapon, Foley, VO, music, vehicle etc. that sets the reference in terms of loudness, frequency content (especially bass content), transients and compression, amongst other variables, that then guides the creation of further assets within those families.

Mixing then starts as soon as you have two sounds. There should be sub mixes and alignment of assets ongoing as a continual process. All this work is needed to make for smoother mixing and less issues to fix down the line, so the mix never gets broken or drifts too far from the target.

A schedule of key milestones – i.e., major reviews or showings, should be noted to get a good mix ready in time – this pacing should be quarterly, roughly, during preproduction and tend toward monthly during the last year of production. Special plans need to be made for platform and hardware mixes (i.e., different consoles and speaker vs headphone considerations).

Do you prefer one person to own the responsibilities of the mix or do you believe in shared ownership?

Mixing is often a collaborative process in games: put it this way, mixing is also part of the implementation of any audio content, as anything that varies in amplitude based on variables also affects the overall balance. But I agree there should be one person responsible for the mix, but that doesn't mean they have to do all the mixing work. That person must ensure the mix gets done and that all work adheres to the vision and meets the goals (and that

these goals and benchmarks are clearly and well defined). The person in charge of the mix can ultimately, if needed, be the final arbiter when it comes to decisions around the mix. That person could be the audio director and they could employ a dedicated mixer to help achieve their goals.

I also believe that everyone who contributes content and implementation strategies is also helping toward the mix and their voices and opinions are equally as valid at the table. Everyone making audio for a title must know and be aware that they are affecting the mix at all times with their work and should adhere to guidelines, standards, and targets, so there should be no 'fix it in the mix' attitude allowed.

Game audio mixing is a team sport, but it is generally the responsibility of one person (i.e., audio director, audio lead, or one of the most senior people within the audio team).

Game mixing often has two main aspects to it: content mixing and live mixing. How do you like to approach both aspects of the mix?
Ideally all the content, implementations, strategies, and systems we build work perfectly with assets we create, both individually and together with other systems, and there is no need to mix. This is rarely, if ever, the case!

The systems usually work exactly as they should, but it is we, the designers of the systems, who are at fault. We tend to design the systems for the 'generic' case, one rule to rule them all, but when we mix, we tend to mix toward the 'specific' case. Mixing in many cases is overriding, taming, offsetting, and in extreme cases purposefully breaking or even bypassing these systems to get the desired result. Hopefully in most cases the systems work, but we are fickle creatures and having everything perfectly handled by the systems we have created never feels quite right, that's when we need to get hands-on.

I think the reality of this is that no matter how good your systems are they will never 100% replicate what it is we want to achieve and this is matched by the fact that perfect is rarely interesting. Dirt, mistakes, errors, distortions and artifacts, whilst in some cases undesirable, are actively encouraged in other areas. Rules are just there to be broken right? A good initial guess that means there is less distance to travel to the desired result is a fair and sensible approach. Try, yes, to get the systems to do it all, but be aware there is always going to be more work to do. Content mixing and automation gets you part of the way there, the 'better' your systems the closer you get to the final goal – but there are always tweaks needed!

On top of any specific mixing goals you may have for a title, mixing in games is usually about improving the clarity of information provided to the players at any moment in time. It can be a challenge when

hundreds of voices could play simultaneously. What are your techniques and considerations to improve readability in a game mix?
Maybe 20 years or so ago we got to a point with games where we could play too many sounds. When too many sounds play it's chaos. Information is lost. Intent is obfuscated.

In my experience culling is the first tool in the mixing toolbox. We remove material so that our intent is clear – which in the case of games I have worked mostly on is the preservation and presentation of information, but for single-player titles could equally be the narrative red thread, the embedded, emotional sound.

The two main advantages are that it's easier to mix fewer things (provided you didn't cut anything important), and playing fewer things means we can have more expensive sounds. The analogy here is you either have 100 Christmas presents to buy for 100 USD, or 5 presents to buy for 100 USD. In the first case it's 1 USD for each present, in the second it's 20 USD. The same can be thought of when playing back sounds in a game, where the money is swapped for resources – memory, CPU load, seek times etc.

There are different great possible culling techniques, such as voice limiting, or nearest three, but they come from a performance optimization origin and are not usually something a 'mixer' would do. They were primarily designed to handle resource constraints. HDR on the other hand is replicating what a mixer would do in removing excess that would muddy a scene, from a mixing point of view. Ducking and side-chaining solutions can be seen as similar to a HDR approach.

A system like HDR should cull away sounds that will be inaudible within the current window of dynamic range even before they are initialized. HDR works on prioritizing sounds, with end users (developers in this case) setting these priorities. In the normal case this is 'loudness' and for example in Battlefield this works perfectly as louder generally equates to 'kills you faster' or 'more important'. The goal with those titles was to allow us to encode as much information into each cue as possible, but then mix in such a way that the information could be readily decoded by a player/listener so that they could make better decisions and play better. Lucid mixing to enable player agency. Play less but make sure you play the relevant 'right' things.

When working with frequency bands, do you do most of the work on the contents (and bake or render it), or do you like to do it in-engine?
I generally prefer to bake equalization into the asset, because EQs outside of the game engine are usually of a better quality – hardware, plugins etc. Cheap (CPU wise) EQs sound cheap, especially when adjusting frequency parameters (sweeping) in real-time.

EQ at run-time is also an extra CPU cost, so I would be careful with it but perhaps still use it for taming, like removing bass, or for effects like the classic underwater/tinnitus effect. Then I would do a pass on the master to remove very low bass on smaller setups (i.e., TV speakers, earbuds etc.).

When dealing with equalization (not my saying but) 'bass is the currency of size/power'. Know how much bass is expected in each type of asset – light switch compared to RPG, footstep compared to tank rolling past.

Beyond bass contents, also pay attention to any gaps you make in the mix to push content through. If you are ducking an ambience to allow a gun tail to ring out check your frequency content and noise profile. The 'hole' you carve should match what you are cutting it for (!) or else you will feel the gap.

If you have a loud sound with a strong visual cue happening far away from the listener in an outdoor space, would you generally do anything to cope with the light/sound speed difference?
Yes, we would play into the learnt experience. We see the flash and then hear the boom. As with lightning and thunder, 1km away delay by approximately 3 seconds. A simple rule is to start with authenticity and try to adhere to the laws of physics. If that doesn't work then go for the awesome. Great if you can be both authentic and awesome. I think it's easier and more effective (most of the time, rules are meant to be broken) to lean into the audience's expectations. That delay will play into the 'wow that was loud' and it took time to reach me. If you get it right people will 'read' it correctly. But audio is not solitary, all other disciplines must support that story – visuals, effects, haptics, etc.

From your perspective, what does the mastering of a game consist of?
Mastering, at least for me in games, is mostly what you do to the mix to make it adhere to or follow guidelines and/or design requirements. Be that loudness standards, target platform (say mobile vs console), playback device (say full range ATMOS vs earbuds) or possibly creating special effects (e.g., War Tapes, or Indent Mode from the game *The Ascent*).

Any last word of advice you would like to share with us?
Mixing is not postproduction. Don't leave it (all) until the end.

Chapter 8

Acoustics

Define your acoustic strategy and goals

In postproduction, it is quite common to use different reverbs for sounds of a different nature within the same space (i.e., ambiences, effects, dialogues, and Foley). The goal is then to embellish every element of the soundscape depending on its sonic characteristics. Other reverb templates can also often be used on top of the 'acoustic' ones to provide special emotional effects in the mix at key narrative moments of a film. Such an approach with three to five reverbs running in parallel and per locations is often overkill in games because of obvious CPU performance considerations. You often need to define a strategy for your acoustic treatments, and pick your battles.

> 'I usually have five reverbs sizes in my template: small, medium, and large size interiors, an exterior 'slappy' space, and a floating one that I can automate in real-time during the mix, which often ends up being a very long and very lush one used in very stylized moments of the film. And I'll have a set each of those for ambiences, for effects, and for Foley. I can then also change the parameters of those reverbs at various times in the film'. (Tim Nielsen)

Before getting started with implementing reverb and delay effects in your game, try to set a direction with goals for your acoustic design. Reverbs purposes can vary greatly from one title to another: it can be about delivering acoustic simulation, or having enough accuracy to

sell the acoustic space to provide a sense of realism, and/or to simply glue things together within the same environment. It can also be used to create depth, add a cinematic feel, enhance emotional moments by playing with hyperrealism for specific locations or moments in your game, etc.

> 'Reverb is great for gluing sounds together, and establishing a coherent soundscape. I like to use the more spatially generic, musical reverbs as they excel in precisely that. Most of the sounds I create will have some baked-in first reflections – not to suggest an actual space but to indicate something about the size of its source'. (Martin Stig Andersen)

When it comes to implementing reverbs, a common approach in games is the one of a reverb 'zone' (or 'room' approach). Every location in the game that could justify having its own acoustic is considered a zone (or a room), and then every sound that is sending signal to the game acoustic will go through those reverbs, depending on the listener's and/or the emitter's position in the world. One or multiple reverbs can be computed per space simultaneously, and then cross fading reverbs in between reverb zones for smooth acoustic transitions. The reverb algorithms are calculated at run-time, so the more reverb per space (if you adopt the strategy of using different acoustic treatments per locations based on the sound types) the more CPU will be used.

> 'In exteriors on *Uncharted 4* and onward we utilized a special secondary reverb per outdoor space that was designed specifically for gun tails. The IRs on those second reverbs were more appropriate to the style of tail that we were trying to reproduce in those spaces. Sending any other elements to that special reverb would not have been appropriate. Even then some of the elements of the weapons were sent to the same reverb that was used for voice and other elements to help marry the two reverbs together'. (Rob Krekel)

While reverbs are obviously great for many possible purposes, it usually does not sound great to use only one reverb per space for very different sound sources. For example, a reverb that would sound beautiful on dialogues could do a decent job for Foley and props, but would unlikely translate well for high-SPL sounds like gunshots or

explosions. Defining a strategy for your acoustic is all about defining what are the most important sounds within that system, as well as the color and the character you want to add to your game experience. If your game is narrative and dialogue centric, then perhaps get the reverb to sound great on dialogues first, and then evaluate if that reverb works well when sending other sound types (i.e., Foley, props, objects, ambiences). If it sounds good, great, but if it doesn't then you would have to decide if you want to make compromises on your dialogues reverbs, or if you can leave with less reverbs on other elements of your mix. In other cases, if your game don't have many dialogues but is heavy on guns and explosions, perhaps you'd want to craft your acoustic to embellish high-SPL sounds, and then evaluate how that translates with other sound types.

> 'The spatial shape of a sound and its perceived source size is sometimes referred to as intrinsic space, and I like to use a first reflection algorithm that suits the specific sound I'm working on. The in-game dynamic reverb, on the other hand, primarily serves as an extrinsic space, a space in which we place the sounds'. (Martin Stig Andersen)

Reverbs are great to embellish the soundscape and to 'glue' every sound together in the same spatial environment, but they can also be very useful to increase or reduce the focus on elements of the mix.

The type of reverb algorithm to design and the technology you have access to should inherently be connected to the strategy you want to adopt for the acoustic rendering of your game.

> 'Acoustic accuracy is certainly important, as is emotional engagement for narrative driven games. Another thing that reverb can sometimes be utilized for in games is sound propagation. It's not just acoustic accuracy for aesthetics then, but rather an essential element for relaying tactical information such as enemy positions'. (Rob Krekel)

EQ your auxiliary busses pre- and post-effects

Independent of the adopted strategy for your acoustic rendering and the technology you are using, there are a lot of frequencies that don't

need to be sent to your acoustic effects. In reverbs, low frequencies would make your mix messy, and high frequencies have a tendency to sound too piercing. It is a good habit to start by cutting the low-end and the high-end of your auxiliary busses before the signal reaches your effects. The classic EQ cutting anything below 450–600Hz and anything above 7–8K can be a good starting point. Then adjust to your taste.

Besides cleaning the signal pre-effects, your effects can also use some sculpting such as any other sound sources in your mix. Here again, use subtractive equalization for your effects to blend better with the rest of the mix aesthetic, and to avoid any undesired masking. You can proceed with that sculpting equalization pass by listening to your effects in the context of the mix. If it does not sound obvious enough, then bring up your effect busses by a few dB to make your equalization pass easier. Put it back down when you're done. Another technique is to monitor only the 'wet' signal from your effect bus for that equalization-carving pass. However, be cautious of working on things in isolation without other sounds in the soundscape being present. When done with your equalizations, A/B test in context and fine-tune.

Don't hesitate to compress your effects

As it's preferable to control levels by tuning playback volume instead of reducing the dynamic of audio elements in the mix, it is not uncommon to have inconsistency in the dynamic range of your effects: delays, reverbs, etc. Working on reducing the dynamic of your effects could help smooth these inconsistencies and allow them to sound naturally more 'present' in the mix. Alternatively, if you think your effects still feel too excited by the send signals, then applying a compressor pre-effect would allow you to control the transients of the signal being sent to your effects.

Calibrate your effects

To ensure effects (in particular reverbs) are always controlled in your mix, and considering you will likely have to use the same send levels on a per-source basis across different locations in your game, calibrating your effects is important to provide a consistent sounding acoustic experience. The idea here is to not have locations with overly louder or quieter reverbs, especially for spaces of the same type or sizes (except if designed that way on purpose). This step is obviously

more important for large systemic games. While compressing your effects might help as mentioned previously, another way to calibrate your reverbs or delays is to generate a white noise loop and send that signal to your different reverb busses. Then monitor the wet signals of your effects of each auxiliary bus to calibrate your effects loudness. Be mindful of not making your mix sound too flat by calibrating all the reverbs perfectly. Different locations of different depth, height, and width will likely need to have different loudness targets. Your mix will sound more lively if you set different loudness benchmarks for indoor and outdoor spaces, and per type (or size) of space, or per type of absorption or reflection space. For example, mixing indoor reverbs louder than outdoors would generally provide a more natural sounding experience. Then the reverb of a small indoor room made entirely of concrete would be louder in the mix than the reverb of another room of the exact same size but with more absorbent wall, floor, or ceiling materials (or filled with absorbent props like carpets, curtains, sofas, etc.). Once all calibrated, re-adjust your auxiliary busses to your taste and in-context to add the necessary desired contrast between different spaces of the game. It is usually good to have all effects calibrated during the macro mixing phase of a project, and then to break the rules and work on instinct and emotions during the micro mixing phases.

Keep some sounds dry if it sounds better

Every sound does not need to be sent to your acoustic system(s). This can be even truer for sounds that are more in the low range or for creating 'close-up' effects. Don't be scared to save some space in your mix by having some audio cues sounding entirely dry. If you're not sure about what to send to your auxiliary sends, then send everything, and try to remove the sends for some elements of the mix along the way. If you cannot tell the difference or if it makes your mix more engaging and clear, then it probably means you don't need to send those sounds in your reverbs. Finding the right balance and formula for different types of sounds can take time, but is a necessary effort to make your mix more impactful while still sounding convincing from an acoustic standpoint.

Mix the reverbs a few dBs quieter than you originally thought

Once you're done with all the balancing, and all the elements of your mix that need it have their auxiliary sends logic and formula

implemented, then monitor your mix with other people in the room. Ask around if your mix feels too dry or too wet. If you don't have anybody to support you in monitoring your mix's 'wetness', then when you feel it fits well in the mix, try reducing your auxiliary busses by a couple of dBs. It is more likely that your mix will sound too 'wet' than too 'dry' after working on your effects and sends logic for a while. Another way to test this is to lower the auxiliary busses all the way down, and bring it up in the mix while playing the game to find the sweet spot. Then read the difference between your previous level and the one you end up with. Remember this difference in dB, it could allow you to save time in your next mixes by understanding if you have a tendency to mix effects too loud or too quiet, and by how much.

Talking to: Martin Stig Andersen, Composer and Game Audio Specialist

Martin Stig Andersen is an award-winning composer and game audio specialist, with his background in electroacoustic composition influencing his approach to game audio development and implementation. Martin created and directed the audio for *LIMBO* and *INSIDE*, followed by focusing on interactive composition when scoring titles such as *Wolfenstein II: The New Colossus*, *Control*, and the recent release *Back 4 Blood*. He was also involved as an ambient music designer on *Shadow of the Tomb Raider* and has recently re-mastered the audio for Thekla's upcoming *Braid, Anniversary Edition*.

When starting a new game project, how do you like to plan your mixing?

In the beginning of a project I like to pick just a couple of overall goals for the mix that will complement and enhance the game. On *LIMBO*, for instance, an initial goal was to play only a handful of sounds at any time. The idea was to mimic the technical limitations of the cinematic era which the art style references. Relatedly, another goal was to make the game quiet, occasionally making it appear as a 'silent game' (sometimes the only thing you hear is optical noise), requiring a high dynamic range, which was a rare thing in games back in 2010. I remember when launching *LIMBO* on the Xbox after playing another title you couldn't really hear anything unless you turned up the volume considerably, a characteristic that met quite a lot of resistance from the team. There weren't any loudness requirements back then, but interestingly the title falls within today's recommendations.

To me the process of reaching the set goals is highly iterative – what works, what doesn't, when to persist or finally abandon a goal. During the process it's good to set aside a bit of time to build a rough yet transparent mix hierarchy that will enable you to quickly test ideas. I often find that when absorbed in implementing new sounds I can't even bother to create a new bus or do manual routing, and I end up creating a mess for myself.

How do you make sure you're making the right creative choices when mixing?

I feel that the more solid a mix I can create, the easier it becomes to deviate from the norm. This has probably to do with the fact that we're accustomed to hear – and to some extent accept – bugs when playing games. So if my base mix is vague, bold moves will potentially be heard as bugs. When doing *LIMBO*, for example, I continuously received bug reports from Microsoft regarding the boy's footstep sound disappearing in a sequence during a

'rotating room' puzzle, and I would have to convince them – and sometimes also coworkers – that it wasn't a bug but a mix decision. It was inspired by a dreamlike shot from Felini's *8 ½* where a character approaches the camera in complete silence, and interestingly the atmosphere it brought about in *LIMBO* ended up inspiring the team to insert a dreamlike sequence in which the boy encounters his sister.

I think we're moving slowly away from the paradigm where a game's mix is largely limited to being the result of a game-wise global mix setup. This is not to say that a global system can't be experimental or bold, but often I miss mixers asserting themselves in service of the structure or narrative of the game.

When making bold mix choices you are certainly going to expose yourself to criticisms, and there'll be team members who dislike what you do. I usually ask myself what hurts the least – getting negative feedback from people (which you need to welcome) or playing the final game without having made the effort to realize my best intentions for the game.

An important aspect of game mixing is about mixing things over 'time' to deliver a mix that feels alive and dynamic. How do you like to use this mix technique?

One thing I've learned from watching films is utilizing the sonic equivalence of an establishing shot. For example, when entering a new location, the sound can inform the player about the sonic environment they're in, and as soon as this is imprinted in the player's mind, we can start gradually deviating from it without changing her/his sonic interpretation. Say, if we enter a loud factory environment we can briefly have it be actually loud only to start attenuating it in order to avoid it becoming annoying, and to allow for other sounds to come through.

On *LIMBO* and *INSIDE* I wanted to establish the environments as being quiet, and the way to achieve this was to make it so, relative to the boy's Foley sounds. However, keeping the mix balance that way, the Foley very quickly became annoying, almost appearing to be loud. So the solution was to start attenuating the Foley after the boy had been running for around 5 seconds, which was enough time to establish the environment being relatively soft. As the boy keeps on running, the Foley continues attenuating quite drastically over the next 30 seconds or so, yet, again, without changing the player's perception of the loudness of the environment. However, when the boy stops running, the volume of the Foley bus slowly increases, eventually reaching the initial level. This would happen if the player was inactive due to thinking about how to solve a puzzle or simply had to put the controller down for some time. The same trick is used when, for example, changing surface materials – the volume would jump up 1.5dB or so, only to start resetting after a couple of seconds. I think that one of the reasons why this technique helps make sound effects less

annoying is that it represents how perception operates in the real world. For example, if I go for a walk I might briefly notice my footfalls when entering a dirt path, only to filter it out completely after a few seconds. As with anything else 'cocktail party effect' related, when dealing with recorded materials, this sort of mental filtering needs to be somewhat simulated by mixing.

The same concept can be used to create contrasts between moments of a narrative journey as well. What's your approach to mixing over time in that case?
By using broader mixing strokes the audio can also support or establish an overall arc. I often find inspiration in structures of sonatas, symphonies and the like, and can't help thinking in terms of exposition, development, and recapitulation. Finding the right balance between tension and release is essential to give a sense of direction to the overall experience. Accordingly, I like to have intense moments but then also longer stretches of time where you hear only the most basic sounds, giving the player a moment to rest, and re-establishing a clear contrast to what's 'loud'. In a couple of instances in *INSIDE* I was able to move beyond the faders and influence the game design in such a way that it would support the structural trajectory that was developing in the audio. For example, before reaching the climax of the Shockwave sequence the audio needed to calm down for a moment in order to avoid listening fatigue on the part of the player. So I suggested that the boy enter a building for a moment, which allowed for occluding the loud shockwave blasts. The biggest challenge in regards to having an environment being loud is finding moments where the game allows for it, for example by having a time out function, preventing the player from getting stuck in this scenario. In the above Shockwave example, the environment is loud only when the boy is out of cover and at risk of being blown to pieces by the shockwave. As the shockwave is recurring every 6 seconds, we know that this is the maximum amount of time that the player will be exposed to the loud environment at a time.

Reverbs, delays, and the perception of an acoustic space can vary greatly between games and between different locations or moments within a game. There are a lot of creative possibilities, but usually coming with CPU limitations. How do you deal with acoustics in games, and what are your creative and technical considerations?
Just as reverb is great for creating spaces, it's also great for gluing sounds together, and establishing a coherent soundscape. I like to use the more spatially generic, musical reverbs as they excel in precisely that. Most of the sounds I create will have some baked-in first reflections – not to suggest an actual space but to indicate something about the size of its source. In

electroacoustic music this is sometimes referred to as intrinsic space, and I'll use a first reflection algorithm that matches the specific sound I'm working on. The in-game dynamic reverb, on the other hand, primarily serves as an extrinsic space, a space in which we place the sounds. In *LIMBO* I was using only a single preset for this throughout the game, with no first reflections, only changing the volume and decay time. The idea was to replicate a plate reverb, which seemed to fit the overall aesthetic of the game. There was also plenty of room to do experimental mixing with the reverb. For example, during the opening part of the game you encounter a boulder on a tree log. As you approach it the ambience fades away and the reverb on the boy's footsteps gradually becomes very loud, bringing about an artificial, almost empty theater effect. Masked by the smashing of the boulder when solving the puzzle, the ambience and reverb are reset.

When it came to mixing *INSIDE* the possibility of using dynamic convolution reverb in Wwise had arrived. I had been using a lot of 80s digital hardware for offline processing audio in order to achieve a slightly gritty retro sound, and with convolution we had the possibility to sample a hardware reverb and use it in-game. So we acquired a Roland R-880 Digital Reverb, their 80s flagship unit, and programmed all the reverbs you hear in the game (PC and consoles). The reverb was perfect for the game as it has this sort of gloss sound while still sounding early digital, and it had some nice sounding DA-AD converters that we used when capturing the impulse responses. We were able to run multiple IRs concurrently in-game, and blend between those, which is probably most noticeable in the shockwave area. There's a big reverb that you only hear when out of cover and hence in danger, and during the 6 seconds shockwave cycle, the volume of this reverb changes from silent to incredibly loud. The idea is that the reverberation gets sucked into the background, as a sort of vacuum effect, during the seconds leading up to the blast, and then hurled into the foreground following the shockwave. By contrast, when the boy is behind cover we hear a much smaller and more intimate reverb. One of the factory presets that came with the Roland R-880 reverb (which had to be typed in manually) had an over-the-top hyped quality that we referred to as the 'Mario' effect. Not that it had anything to do with Mario but it had this gratifying quality, which served well as an 'audio cookie'. So when jumping down from the first Rotator in the Shockwave area, after having solved the puzzle, you'll hear this reverb as the boy lands. However, making the same jump without having solved the puzzle, leading to a certain death, you'll just hear the regular one.

The benefit of using this more musical sounding reverb was the character it afforded rather than its ability to replicate the reverb of a real space. It also helped blend sound effects and music, and whatever reverb was added to the boy's Foley was added to the in-game music as well.

Chapter 9

Space

Filter sounds in the extremities of the frequency spectrum to put sounds over distance

When it comes to putting things over distance to mimic how sounds behave in real life we rely mainly on playback volume, acoustic sends, equalization, and sometimes some subtle dynamic reduction. Filtering and getting the right playback volume for sounds playing over distance are probably the more important steps to create perspective in a game mix. In games, volume changes over distance sometimes need to be faked in order to provide the necessary gameplay feedback or narrative information, making some of the distance attenuations unrealistic. Equalizations then play a big role and become very important to sell the sense of distance and add depth in a mix. For equalization work to simulate distance, the most common technique consists in rolling off the high frequencies, while keeping the lows under control. High and low shelves filters, used in combination with high-pass and low-pass filters, often sound more natural than using low-pass and high-pass filters alone. The shelves are used to mix things in space while the pass filters are used to remove frequencies that are not needed in the extremities of the spectrum to de-clutter the mix.

> 'A very gentle EQ low-pass or high-shelf rolling off some highs over distance helps to simulate an "air filter". But I find aggressive use of EQ usually makes things feel unnatural and can be a pain to manage on a variety of sources'.
> (Rob Krekel)

In real life, high frequencies get absorbed more than low frequencies at distance. The further away a sound source, the more high frequencies

are attenuated. Start by applying a high-shelf and low-pass filters attenuating the mid-high and high-end of the frequency spectrum to put things behind in your mix. Equally, this means you can create a sense of proximity with a sound source by boosting the high-end a bit. Then adjust the low-end of your sounds to keep the spectral balance in control.

> 'To put things over distance, I like to use a combination of level, EQ, reverb and early reflections. So drop the level, roll off a bit of high-end, more wet and less dry on the reverb and then start to use a delay or reverb plugin that has controls over the early reflections to "set" it back into the space a bit'. (Tim Nielsen)

Balance your pre- and post-fader acoustic sends to set them backward in your mix

Often, for things to sound close you need other elements to sound more distant. The human brain processes spatial information better when comparing sounds in relation to others. It is always important to create contrasts in a mix. A common technique to put sounds over distance in a natural way is to use the acoustic of a place to make it sound more 'wet' over distance and more 'dry' when the emitter is near the listener. While a sound source stimulates its surrounding environment the same way independently of its distance to a listener, it is the perception of this source when in the same acoustic space as the listener that makes the reverberation feel more prominent. The amplitude and high frequencies of the source decrease more over distance than the amplitude and high-end of the corresponding surrounding acoustic (usually representing a larger area than the point source, thus being 'closer' to the listener). It usually works well to work with pre-fader FX sends to make the signal more diffuse at distance. Finding the critical distance threshold is key to have things sound natural. After a certain threshold things tend to sound artificial (or heavier processing might be needed, often directly applied on the source contents). Once you found the sweet spot, set your maximum reverb sends volume at that distance threshold, and reduce the auxiliary send volume when sound sources are getting closer or farther. As the sound source decreases in amplitude over longer distance, the reverb sends volume will also decrease with decay relative to the direct sound. In constrast, the closer you get from a sound source the

more direct signal will be heard, and the less reverberation you would want to hear in a game context. The idea is to leave space for the direct signal when a point of interest is close to the listener, creating a sense of focus in the mix.

> 'Reverb is my first go-to for pushing sounds into distance convincingly. Using an inverse curve over distance for the wet and dry tends to work best for most applications'. (Rob Krekel)

Early reflections at emitter position are great to keep focus in your mix while still providing depth

While late reverberation is great to sell space, add depth, and glue sounds together within the same space, it can also have a negative impact on intelligibility or 'comprehension'. You might want to put a sound behind in the mix while keeping the focus on it; early reflections are great in this case to add depth in the mix, and reduce masking, making a mix more spacious without making it 'diffuse'. It is quite common that the positioning of a signal is perceived more accurately when using early reflections calculated at emitter position instead of late reverb. For example, in an action-adventure game with a 'walk and talk' feature, the player would have to follow a friendly NPC through a level, and that character would provide important narrative or gameplay information. In that case, you would want to make sure the NPC voice is clear at all times, while also providing a sense of distance relative to the listener's position. Using a pre-fader send on your late reverb could sound quite natural, but would get in the way of intelligibility. Relying more on early reflections at the emitter position instead of the late reverb alone will very likely result in making the NPC dialogue still sound convincingly distant, while also keeping the intelligibility of the voice lines. Those reflections, coming right after the direct signal, will feel integrated with the direct sound, making it feel more 'warm'. When using such a technique, you could decide to aim for an accurate early reflection approach, or a simplified one (i.e., by simply creating an almost exact delayed copy of the direct signal), depending on the technology and tools you have at your disposal. One of the important things is to ensure to keep enough flexibility to control how 'dry' or 'wet' your signal sounds over distance.

Beyond dialogues that are meant to be intelligible over distance, this technique can also be applied to other sounds that are important to

gameplay or narrative 'comprehension'. It is also an efficient way to differentiate sonically different sound families. 'World building' or non-critical gameplay or narrative sounds could then use a more diffuse signal with late reverb over distance. Critical sounds on the other hand could use emitter-based early reflections with less late reverberation to keep those sound signals focused, clear, precise in space, and intelligible or 'comprehensible' at all times. If the sound mixture feels too disconnected from the rest of your soundscape acoustic, you could send your early reflections to your late reverberation to blend things a bit more together.

Use different acoustic treatments for high-SPL sounds over large distances to create a nice sense of depth in your mix

High-SPL sounds are great to naturally enhance the sense of depth in a mix as they are expected to be heard from far away, especially in outdoor environments. If you have the technology and processing power to do so, try to use different reverb settings based on the distance of sounds relative to the listener. For long distances, try to dedicate one auxiliary bus with distant sounding reverbs. If you cannot achieve that at run-time for technical reasons, or if you're not sold by the run-time aesthetic, a common technique is to bake the distant reverbs directly into the contents that are meant to play from far away. This distant reverb would use more high frequency damping compared to closer space reverbs, but less damping than the sound source direct signal. It also usually sounds more natural to have this reverb quite mono, and panned in the same position in the mix as the sound source. Being more diffuse, fewer details are usually expected on such types of reverb.

High-SPL sounds are also great to create a more dramatic 'reaction' from the surroundings, once again mostly in outdoor environments or in very large interior spaces. Using delays, creating 'echoes', helps enhance the sense of dimension from the environment. To create depth with an explosion for example, duplicate the blast signal, delay that duplicated signal, filter it more with a pass band filter around −900Hz (on top of your initial attenuation filtering), and blend those signals together. Using run-time modulation for this allows more flexibility and interactivity in your mix by changing the delay(s) time(s) and filtering based on distance to listener, but it can also be costly CPU wise. Working on the contents offline can allow for better 'sound quality', processing the signal with better plugins, but offers less run-time interactivity.

Apply pre-delay over distance for loud sounds with a strong visual cue

To simulate long distance propagation of high-SPL sounds that are associated with strong visual cues, it often works great to apply a pre-delay to convey the fact that light (your visual cue) travels faster than sound. This technique is of course inherently connected to how sounds propagate in your game. Aiming for a realistic approach with sound traveling at 343 meters per second will not always sound convincing in a virtual world. The key is to find the right balance so that things don't feel too disconnected between what you see, what you hear, and when you expect to hear it in the game context. It is all about sound-action association.

> 'For loud sounds over distance, I usually like to play into the learnt experience. We see the flash and then hear the boom. A simple rule is start with authenticity and if that doesn't work then go for the awesome. Great if you can have both! It's usually more effective to lean into the audience's expectations as a starting point'. (Ben Minto)

You ultimately need to find the sweet spot between adding realism to your mix and delivering a great sounding game experience with prompt moment-to-moment feedback. It is more about playing to the listener's ears and brain to create the desired effect rather than providing something completely accurate based on a math formula; but the math formula can often be your starting point.

Figure 9.1 Light and sound speed

Use different positioning settings for different sound families to add further context in your mix

Having a clear positioning strategy for your mix is crucial. The position of a sound source allocated to an object is 'automatic' in games, calculated based on the position of an audio emitter relative to the listener. But the strategy to use to process sounds based on those data is up to the mixing person. Positioning is about making choices to find the right balance between making the audio elements of a mix sound believable in space, and providing contrast between different sound families. The idea here is to classify sounds based on their role. Based on the sound families (gameplay, narrative, or world building), you can use different positioning rules to improve readability in the mix by using panning, reverbs, delays, EQ, volume, or dynamic. Try to think about the sounds that need to be clearly and precisely positioned in your game so that the players can react to the action accordingly in a timely manner. Then create contrast with the sounds that are here to populate and embellish the world. For example, while all sounds will likely be brighter and drier when their corresponding game objects are near the listener, wouldn't you want to make them even drier, brighter, and pinpoint positioned if those sounds were associated with a point of interest (i.e., for navigation guidance, or a point of interaction), or a threat (i.e., enemy getting near the player)? Using the mix to contextualize gameplay cues in space allows you to enhance the player's tactical and strategic immersion, resulting in a more enjoyable and engaging experience. If all sounds were positioned in a game with the same panning and distance mix formulas, your game would possibly sound realistic but it would also sound very confusing.

> 'If you want the player to listen, the audio has to be in service of the game, otherwise they'll start 'filtering it out'. Even when an environment of the game calls for a lively ambience I'd be careful about having distinct, positioned elements as they can easily distract the player's attention. Anything that hasn't to do with gameplay will remain relatively distant, diffuse, and spatially static'. (Martin Stig Andersen)

While you might want to aim for a hard-panned positioning approach for gameplay sounds, the way they are filtered and their dry-wet acoustic balance over distance will also all help to make those

sounds stand out more in the mix. In contrast, sounds that don't directly have a gameplay purpose can be mixed with a more 'worldized' approach, resulting in more diffuse signals with less precise panning. Those sounds will then blend better with the rest of the ambient soundscape to possibly increase the sense of believability and belonging in the game. When mixing your sounds in space, you can always emphasize something beyond what is natural to increase readability, or make a narrative scene more impactful. The challenge can often be to find the right balance to increase readability while maintaining the feeling that everything comes from the same world.

Let's look at 'props' sounds as a case study. It is common in games to have props related to gameplay (things that the player has to interact with to progress in the story or in a level), navigational props (to help guide the player toward points of interest), decorative dynamic props associated with a moving visual cue (things like visual effects or animations, for example a moving crane), and common decorative props without any moving elements associated with them (e.g., a pipe or an air-con unit) that would justify having sounds associated with them in order to make the game world more rich and interesting sonically. If you were to work with that 'props' classification, you could be using different positioning rules to add more context and contrasts in your mix. For example, different acoustic sends levels for different prop types would still allow pre-fader automation sends over distance, making things sound natural and consistent when the listener is moving away from the sound sources. Gameplay props would generally sound slightly more 'dry' than the navigational ones, with navigational props more 'dry' than the decorative dynamic objects, and finally having the common decorative props being the most diffuse to allow their signals to blend nicely with your ambience beds (using them as cosmetic sounds to make the ambience feel more alive and detailed sonically). Besides the different amounts of sends for different props classes, reducing more dramatically the reverb sends for gameplay elements that are close to the listener will also help them pop up more in the mix. So, when in vicinity of a gameplay prop – usually a distance where you are close enough to interact with the object in the game, often called the 'intimate zone', 0–5 meters from the listener – reducing the auxiliary sends level to a point that it sounds almost entirely dry would help to have it pop up in the mix. You can also add clarity and context for players to subconsciously understand points of interest in the world, similarly to what visuals might do to highlight an interactive object with outlines, by using frequencies. For example, making the gameplay props idle sounds a

bit more bright and crisp in the mix when in the intimate zone, while other prop types won't have this added treatment. A lot of that work can also be done at source, when crafting different content types, adding more or less sonic detail to contextualize the object role with sounds. Finally, panning accuracy is also important here. Gameplay and navigational props are probably expected to be more pinpoint (or hard-panned) than both types of decorative props, which can use a less precise panning to be considered more 'ambient' in the soundscape.

Figure 9.2 Sound families in the 3D space

Leverage your speaker configuration and the technology at your disposal to further enhance readability

When working with surround, the center speaker has been used historically in films mostly for dialogues. But things can be approached in different ways too. In games, voices can have different purposes: gameplay voices (things like NPC combat barks, NPC friendly barks – like a vendor in an RPG game trying to attract the player's attention, etc.), narrative voices in cutscenes, narrative dialogues 'in world' (i.e., traveling with an NPC character and talking), ambient voices (idle lines in friendly spaces, group voices 'walla', idle enemy barks in combat arenas for games with infiltration or stealth mechanisms, etc.), and the list goes on. If you are using your center channel primarily for voices, besides using it for dialogues in narrative cutscenes, to give a motion picture feel to your mix, you could also

consider this speaker for narrative voices 'in-world' when the NPC character(s) are within the FOV and not too far from the listener. Sending a percentage of the signal to the center will help support the narrative by improving intelligibility and add focus in the mix while keeping some of the dialogue emitter as positional information. Taking that consideration a step further, you could also use the center speaker for gameplay dialogues to improve intelligibility and readability of the action within gameplay instances. For example, in the context of a single-player shooter, when the player arrives in the vicinity of a combat arena the idle barks could be mixed without using the center speaker, but when the player gets detected you could send some of the 'you've been spotted' enemy barks and other vital gameplay voice stimuli you would want to make sure the player doesn't miss to that center channel when the enemy entities are within the mid-center FOV (and at threatening distance). Doing so would offer more contrast in your mix, and emphasis the sense of urgency of the situation.

But the center channel doesn't need to be exclusively used for dialogues. Any sounds important to understand the action within a gameplay instance could be, to some extent, sent to the center channel to ensure they are clearly delivered to the players. It totally depends on your game genre, but for example in the context of an online shooter with competitive gameplay, you could consider sending a percentage of the enemy gunshots targeted toward the player to the center speaker to further enhance the sense of threat.

If used for sounds positioned in 3D (in comparison with 2D sounds like HUD feedback, UI interactions, radio voices, etc.), an important thing to keep in mind when using the center speaker for gameplay feedback (dialogues or sound effects) is to be cautious in controlling the amount of signal sent to that channel. It would work if the game object emitters are located within the FOV and at a relative near to mid-near distance to the listener. You won't want to lose crucial positional information by sending signals in your center channel for a sound cue located outside of the player's FOV. The further away from the listener, or the less threatening a sound entity becomes to the player, the less could be sent to the center speaker (for example by using a distance to listener variable, or a 'threat' variable).

To keep things sounding natural, independently of the selected strategy for your center channel, it is good not to keep the center channel entirely quiet the rest of the time. A good way to do that is to send other sources with subtlety to that channel, like ambiences, and to send some of your effects as well.

> 'I like to leak ambience and panning across the center speaker, as this prevents a hole in the middle of the mix. Even for surround ambiences, while quad is still used a lot, I find that a 5.0 ambience presentation with very little signal going to the center statically and dynamically can yield a more full and satisfying experience'. (Gordon Durity)

There are of course other ways to deliver a clear mix with readability when dealing with surround systems, and you don't have to limit yourself with narrative dialogues or gameplay cues when using your center speaker. How you'd want to use it depends on the type of game you're making, the creative vision, and the associated creative goals for your spatial mix. For example, you could still free up some space in a natural way on other speakers by using the center channel for player related sounds in a third-person game.

Try to always question yourself about the technology and endpoints you have at your disposal, and how you are leveraging these to best serve the mix. Keep both creative intentions and spatial precision in mind to build your mixing rules. Ultimately, if it sounds more satisfying and helps improve readability, then it's good for the mix.

> 'More recently, I've started to use the center more than sending only dialogues. For example, in a third-person game, I will play the character sounds in the center which helps anchor the hero in the mix. This is a transparent way to keep your spatial mix focused on the things around the player'. (Brad Meyer)

A similar ideology can be applied when working with binaural. Binaural uses phase changes and filtering to trick the listener's ears so that our brain can process this information to place sounds in a spherical way. This processing often affects the color of the sounds in some ways. That sound coloration could then perhaps be used as an opportunity to differentiate better sound families in the 3D space. You could decide to use binaural on gameplay cues, so that on top of providing gameplay information to the players outside of their field of view (providing both horizontal and vertical feedback), those elements will also stand out more in your mix because the 'binauralization' will make them sound slightly different. You could also go a step further and leverage different ways to feed sounds to your 'binauralizer'

plugin, for example using object-based audio for gameplay cues (for better pinpoint accuracy), and create contents in Ambisonic for world building sounds to naturally create contrast in the way the sounds are processed.

> 'I like to create distinct sonic spaces using all the available options. For example when working with PS5 Tempest we can use Ambisonics, object-based, or pass-through, these three sonic spaces creating a subtle but effective sense of depth and separation'. (Loic Couthier)

When you've found the most satisfactory strategy for using technology and end-points to improve readability in your game, use that positioning strategy consistently to ensure a harmonious experience that the player can learn and understand through replayability.

Chapter 10

Mastering

Set time aside for mastering

The goals when working on a game mastering can vary a lot from the mixing performance's goals. You probably don't want to do it all at once. Like in other forms of media, game mastering is a key part of the game audio production pipeline. It should happen at a separate time, so that you can focus on your objectives. Separating the mastering from the mixing performance will make your mastering more efficient. It will more likely result in elevating the production value of your mix. This does not mean that the mastering needs to happen at the end of the project. Rightfully, you may want to have enough time to test your mix efficiently and thoroughly on different playback devices (headphones, surround, Atmos, stereo hi-fi speakers, TV speakers, sound bars, etc.), on different gaming platforms, or to test the audio options your game may provide (e. g., night mode). This can be done relatively early in the game development cycle. Getting mastering related audio settings implemented before the end of your project, with the aim to adapt your mix to different playback devices, also allows other developers to experience the mix the way it should be. Other people working on the game probably don't have access to a mix stage. It's important that everybody in the team can hear your work-in-progress mix in good condition while testing the game at their desk on headphones, or in playtest rooms on different type of speakers. You would then be able to receive more meaningful feedback based on an accurate perception of the soundscape. An efficient method is to plan for a few mastering passes across the game development cycle before any important milestones (i.e., Alpha, Beta, release, etc.) to have the flexibility to make adjustments along the way. It is also beneficial to focus on different goals for different mastering passes.

Similarly to mixing, game mastering can happen sequentially, with different phases focusing on the more 'technical' or 'artistic' aspects of

DOI: 10.4324/9781003351146-11

the job. Before getting into the artistic part, you should make sure the mastering chain is fulfilling its basic technical function(s).

Table 10.1 High-Level Mastering Plan

Preproduction	Alpha	Beta	Gold
Mastering preparation work	First 'mastering pass' (technical)	Second 'mastering pass' (artistic)	Third 'mastering pass' (technical)
Creative brief explaining the game mastering aesthetic and goals.	Loudness and peak fully controlled on all mix versions.	Loudness and peak fully controlled on all mix versions.	All game options available.
Paper design highlighting the game options (output versions, night mode, accessibility features, etc.).	First implementation of all game options and accessibility features.	Equalizations and compression for all mix versions implemented and tuned.	All versions of the game mix fine-tuned.
Basic implementation of the mastering tool(s) and logic.	First listening and testing sessions on all end-points. Notes and feedback tracked, ready to be addressed for Beta gate.	All notes and feedback from Alpha gate addressed.	Loudness, peaks, loudness range under control for all mix versions.
In-game peaks and loudness under control.		Thorough play-through of the game on all available end-points.	Final play-through and profiling of the game master on all available end-points.

When starting the mix of a game, the aim is often for the mix to sound good prior to any mastering. No inserts or effects, and perhaps only very gentle limiting, are applied on your master. During that first mastering pass, the goal is often to ensure the game loudness and peaks are under control. You can also already start providing basic output options (i.e., headphones, surround, sound bar, built-in speakers, etc.). The 'artistic' phase usually comes next. This is where you'd decide to use additional multi-band compression, equalization, etc. to adapt your mix better to different end-points, to make corrections or to add some additional flavor to your soundscape. Finally, the last phase is a more technical one. You should have very little to do other than to ensure

your mix is compliant when it comes to loudness, peaking, etc. for all available platforms and end-points. Testing, profiling, and listening to the effect of your mix on the overall game experience on all available end-points is an important part of that last mastering phase.

If your game has different end-points, focus on one at a time

One of the roles of the mastering person in games is to deliver a consistent sonic experience by preparing different versions of the mix for any possible end-points. When dealing with a large variety of mix versions, it can be more efficient to dedicate time for each version within your different mastering phases. For example, you could have different mastering sessions for different platforms, different playback devices, or different audio settings. The idea is to focus on one thing at a time. It often feels easier to take things in steps. Try to set at least one day aside per version in your planning, per mastering pass. It will help you keep your head straight. Working this way also makes retro-planning easier, defining how many days you may need for your mastering by allocating for example a day per playback device (and possibly per platform). Once your mastering plan is defined for each mastering phase, add a 20–30% time buffer on top to account for any unforeseen challenges that may arise.

Table 10.2 Low-Level Mastering Plan

	Day 1	Day 2	Day 3	Etc.
Alpha waterfall mastering pass	High-end surround version(s)	Headphones version(s)	Soundbar version(s)	Etc.
Beta waterfall mastering pass	High-end surround version(s)	Headphones version(s)	Soundbar version(s)	Etc.
Gold waterfall mastering pass	Headphones version(s)	Soundbar version(s)	High-end surround version(s)	Etc.

For the first mastering phases in your project, to catch more easily any negative changes in your mix, you could start by working on the same version as the one you've been working on for your mix. For example, if you're working in a surround-calibrated studio environment, start by working on the 'high-end configuration' version of your master. Then, after a few days, you could work your way through 'lower quality' end-points. For the last mastering phase of a project (just before release), your master should already be under control, and you should know your mix thoroughly. Little work is expected at this stage. Most of it has

been front-loaded already at the Alpha and Beta stages (or other equivalent milestones). With that in mind, it might be wise to focus on the most common end-user configurations first, and then plan your work in order of importance from a player setup perspective.

Stay true to your original intentions

The mastering process is usually about finding small adjustments to make to your mix while staying true to your original intentions. Don't expect the mastering process to 'save' your mix. The truth is, if your mix sounds bad, it sounds bad. It is then better to spend more time on the mixing process.

While mastering in games is often primarily used to conform the mix to different end-points during the more 'technical' mastering phases, the goal can also be to accentuate your mix intentions during the 'artistic' phase(s). If the mix is well done you should not have to do much except for a little limiting and some small changes to bring the mix up to meet the standards.

> 'A part of mastering in games is what you do to the mix to make it adhere to and follow guidelines and design requirements. Be that loudness standards, target platform/playback device needs, or possibly creating special effects'. (Ben Minto)

As a starting point during your 'technical' mastering passes, try to reduce the amount of EQ and band compression to the strict minimum to only target subtle modifications that are needed for the mastered versions of your mix to sound the way you want. In most cases, the more basic the approach the better, as it will tend to keep your mix sounding natural. But mastering can of course also be used as a creative tool. As for anything game audio, it is recommended to ask yourself the question 'why' you are mastering your game, and what it is you want to achieve with it before getting hands-on. Equalizations and multi-band compressions will be your primary tools for anything more artistic.

> 'For me, mastering in games is about taking the final mix of a game and applying a similar set of tools (EQ, compression, limiting) to enhance or compensate for the users' audio output'. (Brad Meyer)

A/B test your master (a lot) at the same volume as the unmastered mix

The mastering process is a lot about listening to your mix. As part of those listening sessions, you might want to A/B test your master against your unmastered mix to catch any possible unwanted changes. For example, to ensure the frequency spectrum or the dynamic of all your sound categories and effects have not been modified in a bad way. The human hearing curve is not linear when it comes to frequency; our ears and brain have a tendency to prefer what is louder, so in order to A/B your mastering efficiently, you need to compare the master and the unmastered mix at the same level.

You could start by A/B testing the busiest and loudest part of your mix to compare the dynamic, and then move on to the quietest moments of your mix. If you're working on a third-person action-adventure game with shooting mechanics, then A/B test the loudest combat scenarios first to evaluate how your master reacts to that. Then move on to the exploration phases or narrative beats of the game. Adjust, A/B test everything again, adjust, and again, and again.

Monitoring volume is also important to take into account. If the person mastering is the same as the person in charge of the mix of the game, then that person has been mixing the game for a long time in a known environment with a fixed monitoring volume. Keeping the same monitoring volume during mastering as that used for mixing can be beneficial. Try to keep that monitoring volume through the whole mastering session. Monitoring at different levels often results in inconsistencies, or the mastering person becoming tired and 'lost' in the process.

Once you feel happy with your master, try to test your master with the monitoring volume way down in a different session. If you can still clearly hear all the important elements of your mix, then it is likely that your master is well balanced. If you're not sure what monitoring volume to adopt during your mastering process, aiming for your target audience's most common listening level range can be an efficient approach.

Get a second opinion

In games, it's almost always the mixing person dealing with the mastering process and the creation of the different 'versions' of the mix. It's great in a way because mastering in games is about adjusting and not necessarily about fixing things. The mixing person is probably the

one best suited to ensure the aesthetic and main characteristics of a mix don't get lost in the process. However, it is very useful to get a professional second opinion from someone with a fresh perspective, as mastering is ultimately the last signal processing before your endpoints.

Test your master on as many listening environments as possible

The main goal for mastering is to ensure the mix sounds great on any end-points in any listening conditions. While you want to perform your mastering tasks in a calibrated environment (that you are familiar with), things can be approached differently when it comes to testing the different versions of your mix. As part of the mastering listening process, try to test your mix at different volumes, and in as many listening environments as possible. It would allow you to find things sounding off on specific devices or in specific listening conditions. If you find that your master sounds great on your high-end professional equipment but consistently have the same problems across a wide range of other playback devices, then perhaps you need to adapt your master to sound better for the wider audience. For example, if you are working on a console game, a good environment to test your master is eventually your home living room setup, because you are used to watching movies and playing games in that home entertainment environment.

> 'When mastering, listen to the mix in various places and use various devices to see how the mix behaves. Ideally I'd want to play in multiple studios with exceptional acoustics, and try to see if anything needs half a dB up or down'. (Loic Couthier)

Get your level and peaks under control first

The number of tools needed in your mastering signal chain is quite limited. You are usually looking at an EQ, a compressor or a multiband compressor, some additional volume work, and a limiter. That's actually all you need.

An important part of the mastering process for games is to reach the required Loudness Standards, usually set at -24LKFS +/-2LU for PC and console titles, or -18LKFS +/-2LU for mobile titles; both over

a period of time of more than 30 minutes (depending on the game type, expected play time, and platform). Starting to get your targeted level and peaks under control first (working with volume and the limiter) will make the first two steps of the signal chain process easier (equalization and compression).

Think of it like this: the limiter at the end of the signal chain is what will be output from your master. If you start by working on the EQ or dynamic bands first, then the limiter at the end of the chain will affect your balance. The rest of your mastering work will be faster and your mix will likely sound more natural at your targeted loudness standard if you start working on the end of the signal chain.

> 'On my master bus I use a limiter fed by a compressor. The limiter catches any potential stray peaks, and the compressor contains the mix as a whole. I want to use this as lightly as possible just to hold things together and not any weird coloration or pumping. Any creative DSP effects are done upstream in the mix'. (Gordon Durity)

The first steps of any mastering phases would then be to make sure you control your peaks and that your mix is calibrated at the expected loudness standard. As with most things mixing and mastering related, a good mantra is 'less is more'. Make sure you don't squash down all the peaks of your mix. When it comes to loudness, you want your mix to be close to your loudness target prior to any processing on the master.

Use compression to control the dynamic or to glue the mix pre-limiting

Compression is used prior to limiting in the mastering chain. The compressor(s) allows controlling the dynamic (or the dynamic per frequency bands if you use a multi-band compressor). The compressor helps to make improvements that will most definitely 'glue' your mix together. The compressor is also useful to not stress the limiter too much. While it sounds convenient to get a tight sounding mix, games are so dynamic that it can also feel scary to apply a single compressor or multi-band compressor with a single setting on your master. A good way to work around this is to do a bit of dynamic work on the bus level. You could then use different compressors for

different sound categories, with different settings based on the action and scenarios available in the games (i.e., through snapshot callbacks). One thing to keep in mind when working with compression is ear fatigue. If you're expecting players to have relatively long play sessions, then try to target only gentle compression to avoid delivering a fatiguing and eventually unpleasant listening experience to your players.

If you have access to multi-band compressors, you have greater flexibility to make adjustments to your mix loudness across the frequency spectrum. Then, when working on your compression by ranges of frequencies, aim at tackling the work one band after the other. Starting with the lows and moving your way up is often the way to go. If your mix is already under control dynamic wise, the compression or multi-band compression should be quite subtle.

Use EQ to make your mix work best with any environment, or to tune the overall tone of your soundscape

If your mix is already sounding good, and all peaks, dynamic, and loudness are well under control thanks to your first 'technical' mastering passes, the equalization step should not really be about correcting imperfections in the mix. It can of course be used to tune the overall tone of your soundscape by applying shelves and making final adjustments to your master if you feel that's needed, but the changes often need to be subtle to not put the balance of your mix at risk. Equalization work can also be used to ensure your mix sounds consistent across any listening environment (i.e., different playback systems and possibly different platforms). There are two main trends here: some people like to use equalization to 'correct' different endpoint colorations, while others prefer not to make those corrections as the variety of brands and models is too wide. If you decide to use the master equalization to adjust your mix to different possible endpoints, it's good to keep in mind that those end-points (both hardware and software) will do their own coloration to your mix, and that people are used to hearing sound through those devices. In any cases, when using equalization on your master, try to aim at flat curves as much as possible, using primarily a subtractive approach to attenuate things you don't need instead of boosting frequencies. That way, you have fewer chances to break or affect your mix in a bad way, while your peaks and loudness will remain under control.

> 'I don't apply any EQ for device types because the variety is so wide, and even more when combined with acoustics, that there is just no way to be right in my opinion. I aim for flat, and the device/acoustics will do their thing anyway, as they would when playing music or films with that same device'.
> (Loic Couthier)

Independent of how and why you might want to use equalization on your master, while EQ is first on the mastering signal chain, it is often the final thing you want to adjust. It is usually better to have the full picture of the overall mix before making final adjustments. Within the mastering signal chain, every step affects the others, so make sure to work on equalization with the rest of your signal processing chain active of your master. Equalization is likely the final decision you want to make on your mix. Be meticulous, and make sure you do this final adjustment work in a well-calibrated studio environment.

Talking to: Loic Couthier, Supervising Sound Designer

Loic Couthier is a supervising sound designer with 13 years of experience in games. Currently working at PlayStation Studios in London (UK), Loic's work can be heard on titles such as *Returnal* (PS5), *Blood & Truth* (PSVR), and *WipeOut Omega* (PS4 and PSVR).

Mixing games is usually about improving the clarity of information provided to the player at any moment in time. It can be a challenge when hundreds of voices could possibly play at the same time. What are your favorite techniques and considerations to improve readability in a game mix?

Everything that is being triggered in the audio middleware will be prioritized and mixed using traditional techniques like side-chaining (volume + EQ), voice limiting, and states, to make space for what needs to be heard as a priority, at any given time. There can still be way too much content to deal with, so ideally we want to cull content before it even gets into the mix (before the trigger). This helps the mix tremendously even though it's not happening in the mixer.

Now this is easier said than done and requires resources that are not always available (time, audio programmers, budget, R&D).

For example, an intense combat scene in *Returnal* can trigger up to 800 sounds per frame (projectiles being the biggest contributor). On top of the signal-driven techniques (i.e., side-chains, etc.), we use culling, emitter grouping, and voice limiting to control this constant spamming. Essentially, in combat you would hear the most threatening enemy attack at any given moment (enemies), the most important player actions (Selene or UI), and the music (emotional drive).

The rest is either muted or pushed to a quieter background 'noise floor', for scene awareness without masking the priority cues. This directly refers to how the mix structure is organized (per input types). It allows us to control the number of inputs heard, and to have all similar inputs behave as a group, from a mix perspective. When there are a lot of 'similar inputs', they become a 'consistent noise block', which we may either suppress entirely, or promote only the most important actors.

Sometimes, it is the actual gameplay balancing that you need to influence. If some NPCs have trigger-happy behaviors that are all synced, the game will feel and sound really bad. Fixing this requires us to influence the source and talk to other disciplines. Mixing scope goes way beyond the audio discipline.

In many ways, a great mix relies on great editing. Implementation/culling is that editing stage in games. For example, if 13 explosions happen

simultaneously, the system needs to edit this in a way that sounds good and is readable. In a DAW we would not line up 13 explosions vertically without doing anything to them. We may only play three, delay some a little, only use the transient parts until the last explosion, etc. The mix would sound a lot better even though it was all about the 'editing'.

Do you sometimes leverage your speaker configurations or the technology at your disposal to enhance further the readability of your game?
Absolutely, but maybe in a controversial way. For example, I believe that if a 3D audio mix sounds clear in stereo over speakers, you're basically done. This is because it is the most crowded mix you can ever deal with – the whole mix played over a minimum of physical transducers. Headphones are stereo but allow the perception of more details and are more forgiving. I obviously use both, but when it comes to readability/clarity, I like to 'fight' against the most challenging output. I find mixing in surround much easier, because you have more speakers and physical separation. So I like to mix in the most challenging format (stereo), then do the necessary extra work for surround compatibility and subtleties (spread values, signal sent to specific channels, etc.). I use the LFE channel very rarely (almost never), because this would get lost in all the other formats. I want every sound to have the right and same amount of low-end, everywhere. The LFE is only for a few rare moments in cinematic, maybe. Most of the time I rely on the fact that the playback system will have bass management and/or have a full range front system. People may disagree with that. If it is for a cinema experience then I would most definitely use it. But for a home playback with infinite, unknown output device possibilities, I avoid it.

This is all also coming from the fact that the vast majority (much more than half) of our players play in stereo (headphones, then speakers). If one output has to be prioritized to sound the best, it is stereo over headphones (3D or not). So I work with that in mind.

Now when it comes to leveraging spatial technologies, I do create distinct 'sonic spaces' using all the available options. For example for *Returnal*, on the PS5 Tempest we have Ambisonics (3D), objects (3D), and pass-through (2D) available simultaneously. The '3D space' is perceived outside of the player's head (enveloping the head), while 2D pass-through plays 'inside it' (from the left ear to the right ear, going 'through the brain'). Ambisonics envelops the player, objects fly around with pinpoint 3D accuracy and pass-through is the closest you can get to the player. We use these three sonic spaces to create a subtle but effective sense of depth and separation. These spaces are more readable if they are not overcrowded; using the three is helpful to avoid overcrowding one or two of them.

From your perspective, in what does the mastering of a game consist of?

The mastering to me is about adapting the mix to various outputs and audience playback conditions. Speaker configuration types, dynamic range modes, everything that is about translation to the audience playback systems and space. Deciding on which options to offer is also part of the mastering. Listening on multiple devices, and in different spaces, to have an understanding of what you can do to optimize the audio for each of the situations.

I guess it depends on the title, but so far most of my mastering approach in videogames has been on the transparent side, tonally. For some extreme mastering presets such as 'midnight mode', it's possible to get a bit more creative to give a special attitude and character, but usually I try to avoid this because it has a multitude of side effects that I may not want to spend time on solving (compared to other work on the title).

Gain is also obviously a big part of it too, making sure the mix levels remain consistent for all the possible configurations. But diving into this is often closer to mixing than mastering. There's always a lot of mix work involved in my mastering, because I don't only process the master, I also change what's in the mix to accommodate the mastering.

In games, with tens of thousands of assets all going through the master bus, I always try to have nothing to do on the actual master. That being said, I do see and use the mastering chain as a last polishing opportunity. If there is a way to make everything sound a little bit nicer with a gentle touch, then I do it.

I usually use equalization to adapt the tonal balance to a flat target. Normally this is already done on the contents, but sometimes there is a need for a subtle consistent offset. For example Ambisonics encoding/decoding can color the sounds, and an EQ can help bring back a bit of air that is usually lost.

It is also quite frequent that a mix needs to have less low mids. Even though the assets are fine, when they build up it can get busy in this area and the mastering stage can help.

I don't apply any EQ anymore for devices types. This is because the variety is so wide, and even more when combined with acoustics, that there is just no way to be right in my opinion. Any frequency could be up or down 12dB or more. I aim for flat, and the device/acoustics will do their thing anyway, as they would when playing music or films with that same device. The audience listens to mastered material in every media, and I aim to provide that neutral profile. I do not try to fix their system because I don't know it.

I would use multi-band compression for the above examples too (Ambisonics top end, low mids buildups), but only if all the settings of the plugin can be automated dynamically. Games are so dynamic that I can't imagine having one static setting for it all. Combat and exploration have completely

different dynamic behaviors and requirements, in my opinion literally all the settings of the multi-band would need to be different. Most of my mastering dynamics is actually done in the mix.

I leave the 'peaks work' to the mastering limiter, which is transparent and tailored for this, by definition.

I find that strong mastering chains (as in significant, characterful changes in tonality) are very effective at bus level, but way too destructive on the master bus. For example there might be a very cool way of processing the weapons, but that will not work at all for ambiences or for enemies. So I master at bus level in the mix, and am very gentle on the actual master bus. We all know the saying that 'a great mix doesn't need mastering', and I believe in that as an ideal to pursue.

How do you usually like to plan your game mastering?

Other than looking at the specifics of the platform(s) we aim for, I usually start with the design (on paper) of the various options we may offer in the menus regarding outputs and mastering. I do this as soon as possible (pre-production ideally) because it involves UI and UX design, which also involves text localization. These menus will need to be finished and locked way before the final mastering pass.

I set up the overall mastering systems in the audio engine relatively early, so that the various states, parameters or other plugins are already placed where I need them and ready to use. Usually I won't do anything with these until we have a build of the game that is representative enough, at which point I may start with broad strokes that sell the intention and begin to provide a taste of all the options.

At some point in the project production, there will be a benchmark location/level where the content and mix will both be good enough to allow me to further define the mastering offsets. Then I will regularly update these as the game development goes. I try to start early because there can be some mastering modes that conflict with some mixing systems (especially extreme ones like midnight mode). So I want to face these 'bugs' ASAP. This is to give myself more time for the final mastering stage, where I want to focus exclusively on listening and fine-adjusting something that has been working well for some time, rather than setting stuff up and making great changes at the last minute, potentially missing some of these bugs and side effects.

For the final mastering, ideally I want to play in multiple studios with exceptional acoustics, and try to see if anything needs half a dB up or down, based on consistent notes from these multiple places. In the past it has been in two to four places where I trust and know the acoustics the best (my treated home studio, our studios in the office, our play area at the office, my TV space at home).

Chapter 11

Accessibility

Start with a design and plan early

Defining early on, preferably in preproduction, how many accessibility-related mix versions, or options, you would like to provide is an essential step in planning effectively. It is better not to keep accessibility as a topic to be thought of, or dealt with, at the end of your mixing process. Not planning early will add some unnecessary pressure, and possibly create the need for risky late refactoring. Another reason why it is important to plan early is collaborative work. Any options you want to provide have to be exposed in the game's settings menu, which means that you need to work closely with the UX, UI, and localization teams to support this effort.

> 'I usually start with the design on paper of the various options we may offer in the menus. I do this as soon as possible because it involves UI and UX design, which also involves text localization. These menus will need to be finished and locked way before the final mastering pass'. (Loic Couthier)

Designing and planning the work early on is also beneficial to get all the necessary logic implemented and tested thoroughly. Usually, you want all the logic to be in place no later than the Alpha gate, with at least a first functional prototype implemented in the game build. When designing options or mix versions for accessibility, it is always important to question yourself about all the quiet and 'cosmetic' sounds that find their virtue in making an elegant and convincing audio experience, but that are less important to understanding the gameplay or narrative. A good way to sort this out is to build another categorization of your soundscape, on top of the one you have on

your bus structure. For example, try to classify every sound category from your bus structure from highest to lowest importance when it comes to narrative and gameplay 'comprehension'.

After the design and planning phase, the actual balancing of your accessibility mix versions can often be kept for later, until the game main mix version feels under control. Once you know how your mix sounds, making adjustments to adapt your mix will come more naturally. Thinking about accessibility and how it will affect your mix based on your design often also leads to you thinking of things in a slightly different way when crafting your main mix version

Provide options for players to make their own version of the mix

The first step when dealing with accessibility for a mix is to provide enough options for players to make their own version of the mix. It might feel counterintuitive to provide options for people to 'un-mix' your mix at first, but it is good to always keep in mind that based on the World Health Organization (WHO) data, about 5% of the global population are currently experiencing hearing loss. The WHO estimates that this number will go up to over 700 million people (one in every ten people) by 2050. When you realize that nearly 430 million people currently live with hearing loss, then providing options for gamers to adapt the soundscape to their needs makes total sense. Keep in mind that those with hearing loss often have difficulty fully engaging with games. Beyond making the dialogues more intelligible by reducing least 'important' sounds that could mask narrative information, accessibility in mixing is also about making the overall game more 'comprehensible'. 'Comprehension' can be subjective, especially when the mixing person does not have any form of disability, and of course different players will have different forms of disability. 'Comprehension' can be a hard metric to define, or to test, thus a 'one size fits all' approach often does not work. Personalized audio options can provide a good alternative, being an effective solution on top of subtitles for many people to better engage with your game.

> 'Mixing has a role to play in audio accessibility. For example, thinning the mix out intentionally can help players who have trouble with processing information to feel less overwhelmed in busy scenes'. (Rob Krekel)

Providing options to change the mix representation per sound category can be as simple as providing a slider for players to be able to change the volume of your main sound categories, or go as far as providing a lot of granularity with many sub-categories. For example, you could provide a slider to change the volume of your game UI sounds, or taking it further, breaking down different types of UI sounds based on their purpose in the game, such as 'tactical UI', 'HUD UI', 'Notification UI', 'Interaction UI', etc. The same can apply to any other sound types.

A 'Focus Mix' version can be the base for many possible other accessibility mix versions

On top of any volume sliders you may want to provide for people to adapt the mix to their needs, a good option to provide is the one of a 'Focus Mix'. That 'Focus Mix' is often a good starting point to create other alternate accessibility mix versions. It can be useful for example to provide an alternate mix (and soundscape) for people with vision impairment, or different mix versions for people with hearing disorders. When it comes to the 'Focus Mix', 'comprehension' often goes beyond intelligibility. It often means defining the sounds that are important to both 'gameplay' and 'narrative', and making them stand out better in the mix (while intelligibility is often about focusing on the dialogues alone). Creating a 'Focus Mix' is then about triaging categories of sounds per family, making 'gameplay' and 'narrative' sound types more prominent and clear, or precise, in the mix. This mix type is mostly about volume, frequency work, sometimes panning rules and acoustic, with the core idea to contextualize even further your mix.

> 'Adjusting the mix to make room for specifically crafted accessibility elements is critical to making them clear and easy to hear'. (Rob Krekel)

Based on that 'Focus Mix' version, you can then differentiate further accessibility-related mix versions. For example, while hearing loss is often mostly addressed by visual cues, you could also provide different 'profiles' on top of the 'Focus Mix' for people to select frequency ranges that are difficult for them to hear, and make those ranges more prominent in the mix. You could also create a 'Mono Mix' version of your game from that 'Focus Mix'. The 'Focus Mix'

can also provide a base for making a different mix for people with vision issues. For this, you would usually want most of it to be addressed by working on different audio cues, which means that a special mix should ultimately be created. Readability of information is more important than anything else here, so that 'Focus Mix' could provide a solid base to craft other accessibility related mix versions.

Most of the work happens on the bus level, and a little on the game mastering

With a modular enough bus structure there is a lot that can be handled on the busses directly. This is both true if you want to offer possibilities for players to adapt the mix to their needs with volume sliders, and if you want to create a 'Focus Mix' or other alternate mix versions. The goal is often to make your mix even more focused and de-cluttered, removing anything superfluous from a 'gameplay' or 'narrative' standpoint. You could reduce the ambiences, the effects, etc. relatively easily from your bus structure, but also limit the amount of signal (i.e., sound voices) going through your different busses for people having problems distinguishing too many sound cues playing simultaneously. Of course, things could also go as far as re-working a completely different prioritization scheme, re-working audio emitter budgets, spawning rules, or other run-time modulation prioritization techniques. The bus level work should also allow you to provide separate options to remove some audio features or contents entirely, for example things like the classic 'tinnitus effects' in shooter games that could create discomfort for some people. Side-chaining, ducking, or HDR can also sometimes be pushed further, beyond what sounds natural to the mixing person. Doing most of the work on the bus level means having less processing to do on the master. You could then keep the mastering options for things like targeting different frequency ranges for people with hearing disorders.

> 'Mastering can also be used to address accessibility in certain ways too like boosting dialogue to help those with auditory impairments to better hear contextual clues in game. The ways audio can help enhance accessibility goes far beyond just mastering though, and extends into sound design, systems design, and integration with other departments'. (Brad Meyer)

A subtractive approach provides more natural sounding results

Pushing things forward in your different accessibility mix versions to make the game soundscape more 'comprehensive', or to make some frequency ranges stand out more, can be done by pushing other things down. As often with mixing, a subtractive approach sounds less artificial and provides more controlled results than an additive one. The idea is then to remove the focus on what's least important in your mix, instead of boosting volume or frequencies on what's important in your soundscape. For example, consider 'world building' sounds as 'noise', and take those sound categories down. It will make space naturally for 'gameplay' and 'narrative' sounds. Similarly if you want to provide a basic option to have for example more presence in the 2–4KHz range, then favor taking down other frequency ranges around it, instead of boosting with an equalization, or a multi-band compressor, or both, on your master. A subtractive approach will help keep your loudness and peaks under control, not exceeding what you had already with your main mix. It will also avoid breaking your balance, and keep some of the original identity and character you crafted for your main mix version, staying true to your original vision.

Get a second opinion

It is very hard to create mix versions and assess their effectiveness when you cannot test them efficiently as an individual who does not require those accessibility options. It might sound obvious, but don't hesitate to reach out for external help. Try to get opinions from people with actual hearing or vision impairments. It's mission impossible to adapt a mix without being able to listen to it in the right conditions. If you've not experienced any of these conditions, how could you test what you're doing? How could you evaluate if your changes are efficient, good, enough, or not enough? Consultancy can be a good option. You could reach out to specialized doctors or professors who could help you understand these issues better, from a medical standpoint, which would ultimately lead to more adapted solutions for your players. User testing with targeted players suffering hearing impairment, cognitive disorders, or vision loss, could also be extremely beneficial to gather thorough feedback, not only on your mixing work, but also to better understand the needs of these players.

Talking to: Rob Krekel, Sound Supervisor and Audio Director

Rob Krekel is a sound supervisor and audio director who has been working with game audio for about 17 years. Rob has worked on over 20 games, his experience ranging from small projects to some of the biggest AAA games. Rob was at Naughty Dog for about 11 years where he worked his way up from Sound Designer all the way to Audio Director. Some of his most notable projects were *Uncharted 4* and *The Last of Us Part 2*.

What is your first step when starting a game mix?
My approach to mixing games is always rooted in a 'mix as you go' philosophy. On many projects it's often been the case that you really don't necessarily have the luxury of a long mixing period at the end of development. So elements need to be put in at a level that they could theoretically ship at. In the games that I have worked on over the last ten years or so, the focal point was very often the story. That means the dialogue was the most important element of the mix, so we established the level that we wanted to hit for the various dialogue elements and we mixed everything else around this. Making sure we were conveying the appropriate emotional tone and supporting what the story was attempting to communicate was always the priority. Beyond that there were always demos or press showings that allowed us to have a small slice of the game to mix, and then use this as a target for the rest of development. Having a 'beautiful corner' with that pre-mixed game slice can be very useful as a guiding light.

Do you believe the mix has a role to play in providing basic audio accessibility options? What accessibility considerations would you take into account when mixing a game?
Mix absolutely has a role to play in audio accessibility. Adjusting the mix to make room for specifically crafted accessibility elements is critical to making them clear and easy to hear. Additionally, making time and space for things like text to speech where not only are the levels correct but it also fits in timing wise is critical to its utility. There is an opportunity to take mix for accessibility further than that. Providing options to change the EQ of a mix in a drastic way to help players who have sensitivities to certain frequencies could be a good option. Also thinning the mix out intentionally via an accessibility option can help players who have trouble with processing information to feel less overwhelmed in busy scenes. There are lots of things on the accessibility side that are yet to be explored, and there are big opportunities for innovation here.

What sound prioritization techniques do you like to use to improve readability in your mixes?
At Naughty Dog, Audio Programmer Jonathan Lanier coined the term PDR or parametric dynamic range. This system uses game state to drive many different ways of controlling the mix. For example, if the game was in the 'explore' state we could have a lush detailed soundscape with room for everything to play. On the other hand, once the 'combat' state kicks in, several things all happen at once. We had a general snapshot that comes in to modify our base sub-mix levels. We also used that state to start more aggressively culling sounds belonging to certain sub-mixes below certain volume thresholds. This had a two-fold benefit; first it removed sounds that were unimportant to combat so the mix was clearer, and allowed for more room to prioritize sounds that needed to be heard by the players. Second, it prevented these things from playing at all, which has the added benefit of saving voices and CPU overhead. Voice utilization tends to go up during combat snapshots, so this helps a lot to mitigate that increase. We also used additional additive mix snapshots (that we called bias mixes) attached to various game states to help emphasize or de-emphasize various sub-mix volumes depending on the context. For example, while the 'combat' state was active, we sometimes needed to feed more contexts into the system, allowing us to alter the mix further. Is the player firing their gun? Then another bias mix snapshot that pushes and pulls sub-mix volumes to account for that could be enabled. That particular bias mix snapshot pulls down various sub-mixes like player Foley and ambient emitters while boosting others such as dialogue and enemy Foley. Was the player firing their gun, but a melee impact is now playing? Then we'd play an additional bias mix snapshot that will lower the player gunshots and emphasize the melee impacts among other sub-mix changes. These bias mix snapshots were constantly coming in and out and on and off, attached to a variety of game state changes that were being tracked by the engine. The mix changes were generally subtle and quick to not sound obvious, while still improving clarity enough. We tried to account for as many scenarios as we could, and essentially tried to let the game mix itself in those more system-driven dynamic scenarios.

When working on action-adventure games driven by narration, how do you make sure dialogues always have the necessary space in the mix to be intelligible at all times?
In my experience that is something that should be approached from the very outset of the process. Dialogue is king in the mix and anyone on the sound team knows and understands that it needs to be mixed around the dialogue.

Having a wide dynamic range is key for leaving room for dialogue to be able to have a space to play clearly without having to resort to methods like side-chaining. I find that side-chaining tends to not work well for the cinematic aesthetic that we were aiming for at Naughty Dog for example. The biggest challenge for dialogue clarity that we had was an issue that arose from our environmental audio system, and our characters' tendency to deliver exposition while walking and talking through the game world. This led to things like obstruction and occlusion affecting the dialogue too much and in many cases making it unintelligible. We utilized a cleaver method to help deal with this. Whenever a friendly character was obstructed or occluded (we did not do this for enemies during combat) we would kick on an additional send to a sub-mix bus with a very tight slap reverb. It had the effect of helping the clarity of the dialogue but also making it feel appropriately distant and convincingly affected.

How do you like to deal with reverbs in a game mix? Do you aim at providing a sense of acoustic accuracy, or do you use them more to improve the emotional engagement with locations or narrative 'scenes'? Or both?

Acoustic accuracy is certainly important, as is emotional engagement for narrative-driven games. Another thing that reverb can sometimes be utilized heavily in games for is sound propagation. It is then not just acoustic accuracy for aesthetics, but rather an essential element for relaying tactical information such as enemy positions.

When dealing with reverbs in games, generally individual spaces have a single reverb associated with them for any elements that play within. Typically, most 3D sounds are sent to the reverb aux busses. Each sound individually has its own send volume and can be wetter or dryer depending on the context. I usually don't send 2D sounds such as ambient beds to a reverb aux. It's the same with 5.1 set pieces. Those tend to have some reverb backed into them but it's common that those set pieces are not made of a single 5.1 sound but maybe a 5.1 main sound augmented with other mono sounds that do indeed get specialized being sent to the reverb aux. It helps to blend things together to feel cohesive.

In exteriors on *Uncharted 4* and onward we did utilize a special secondary reverb per outdoor space that was specifically designed for gun tails. The IRs on those second reverbs were more appropriate to the style of tail we were trying to reproduce. Sending any other elements to that special reverb would not have sounded good. Even then some of the elements of the weapons still did go to the same reverb that was used for voice to help marry the two reverbs together.

When dealing with distant sounds, things can be a bit different. A mixture of approaches could be the most flexible depending on the needs of the scene or moment. On very distant sounds that are in an environment that the player can never get to we usually bake the specific reverb into the assets. If it's a place the player will get to but hasn't yet, we could also choose to send the sound to a virtual environment that has the reverb assigned to it.

When dealing with large games that could have multiple outdoor and indoor spaces, how do you calibrate your reverbs?
This is one of the bigger parts of the mix process for me. During early development we'd have a basic generic set of reverbs that are populated through all of the spaces in the game. Then as we mix the game we create and add more individual and specific reverbs to areas through the game that call for that level of detail. During that creation process I take elements from the game (typically dialogue and weapons) and run them through the reverb in a DAW, and A/B compare them to other reverbs and tweak them before they are implemented in the game engine. Then I listen back to them in game and make adjustments from there. For example, I found this was a good way to work on the *Last of Us Part 2* as in many cases the basic generic reverb was perfectly acceptable, and fixing to a wide number of spaces that the player does not spend a lot of time in. Even still I made about 150 unique reverbs that are peppered through the game.

From your perspective, what does the mastering of a game consist of?
Generally speaking, I prefer a light mastering touch: mostly to control peaks, and to prevent issues with the output. I would also use it to control the game menu options for dynamic range. I use a limiter for the peaks, and utilize an EQ to prevent issues (i.e., I'd have a low-cut filter to prevent too much low-end information for people using sub woofers). This is especially necessary when using special modes like slow-motion where more information can get tossed at a subwoofer than normal! We do not want to damage anyone's equipment! At Naughty Dog we also used our mastering tools to create options for dynamic range so that even folks who don't have AVRs can have some level of control of the dynamics. It also allowed us to really stretch the dynamic range for players who had setups that could really take advantage of it.

Chapter 12

Last insight
There is no truth, only preferences

Working with sound is not black and white. There is always more than one way to do things. Trusting your ears and following your instincts can get you better results than applying rules. Mixing a game is like cooking a dish: you must choose your ingredients wisely and taste your food along the way to make the necessary adjustments instead of simply following a step-by-step recipe.

While writing this book, I have been trying to add as much nuance as possible. Always keep in mind that there is no truth, only preferences. Mixing can be quite personal, everybody has their own taste, and your approach might differ depending on the pipeline and the tools you have access to. It is important that you make your own choices, develop your own creative and technical opinions. Ultimately, try to always ask yourself this simple question: 'why?' Why do you mix your game? Why would you go with a specific mixing technique? Why would you mix a feature or a sound in a specific way? The answer to any 'why' question will help you to put things into perspective in a more holistic way.

While it can be quite technical, especially in game development, keep in mind that mixing is an art, not a science.

Index

Note: Information in figures and tables is indicated by page numbers in *italics*. and **bold**, respectively.

2D sounds 79, 118, 141
2D space 44, 118, 131, 141
3D audio mixing 130
3D sounds 79, 118, 141
3D space 77, *117*, 118–119, 131, 141

accessibility: bus and 137; design and 134–135; focus and 136–137; hearing loss and 135; mastering and 137; plan 134–135; second opinions in 138; subtraction and 138
acoustic accuracy 102, 141
acoustic rendering 64, 102
acoustics 100–109
acoustic space 101, 108–109, 111
acoustic strategy 100–102
additive mixing 25, 57, 62, 84, 91, 138, 140
agile methodology 16, 24–27, *33*
alpha 32, *33*, 121, *122–123*, 124–125, 134
ambiance 18, 48–49, 51, *52*, 57–58, 66, 90, 96, 99–100, 102, 108, 115, 117–119, 132, 137
Ambisonics 120, 131–132
Andersen, Martin Stig 7, 15, 44, 71, 92, 102, 106–109, 115
art: in collaboration 20; mixing as 143; performance enhancement in 4; in sonic postcard 22
artistic choices 25, 29, **31**, 42, 62
artistic goals 6
artistic instinct 7
artistic micro mixing 73
artistic sensibility 3
attenuations 25, 49, 57–58, 70, 79, 106–107, 110–111, 113, 128
audio accessibility *see* accessibility
audio artist 16
audio calibration 23, 40, 52, 76, 103–104, 126–127, 129, 142
audio code 24–25
audio contents: benchmarking, in planning 21–23; category level 55–56; collaboration and 85; corrections at level of 81–82; implementation of 16, 42, 96; in macro mixing 25; mixing 57–58; previs and 22; source 40–41; sub-category 55–56
audio contents guidelines 42, 71, 99, 124
audio contents mastering 22, 76, 92
audio culling 62–63, 73–74, *74*
audio director 16–18, 46–50, 56–60, 96–97, 139–142
audio emitter culling 73–74, *74*
audio emitters management 73–74, 76
audio emitters priority system **30**, 56
audio end points 83–84, 123–124
audio engine 1, 16, 25, 40, 43, 48, 57–59, 75, 133, 140
audio frequency absorption 110

Index

audio levels 16–18, 37–44, 48–49, 73–75, 116, 126–127
audio middleware 9, 24, 48, 57–60, 81, 130
audio output versions **122**
audio perspective 110
audio pillars 20, 57, 96
audio playback 23, 35–38, 83–84, 99, 103, 110, 121, 123, 128, 130–131
audio positioning 112, 115–116, 120
audio previs 22, 28, **30**
audio prioritization **30**, 45, 49, 56, 61–80, 64, 74, 139–140
audio production 16, 25, 27, 46, 121
audio programming 73
audio sculpting 84–85, 103
audio signal culling *see* audio culling
audio signals: acoustic treatments and 113; ambiance and 117; auxiliary buses and 103; chain processes 127; compression and 94; emitter position and 112; narrative and 118; pre-fader and 111; reverb buses and 104; sound character and 85
audio supervisor 88, 139–142
audio systems 6, 17, 24, 46, 141
audio targets 14, 22–23, 28, **30, 33**, 78, 83–84, 96–97, 99, 104
automations 44–45, 97, 116
auxiliary buses 94, 102–104, 113

backgrounds 17, 40–41, 89, 92, 109, 130
backlog 25, 28
benchmarking, in planning 21–23
beta 32, *33*, 121, **122**, *122*, **123**, *123*, 124–125
bias mix 140
binaural mixing 55
bus level, accessibility and 137
bus structure 51–56, 58–59, 75, 135, 137

calibration 23, 40, 52, 76, 103–104, 126–127, 129, 142
categorizing sounds 51, 82–83
center channel 90, 119
child buses 59

clarity: information 97–98; sound 2, 87
close-up effects 104
collaboration 16, 26, 42
comprehension 135
compression: in artistic phase 122; to 'glue' things 93; hesitation with 103; leveling *vs*., to control volume 92–93; mastering and 124, 127–128; multi-band 124, 132; multi-step 95; naturalness and 95; parallel 93–94; tonal 94–95
concept phase 28, **30–31**
console games 37–39, 84, 99, 126
content mastering rules 22, 40, 42, 76
context 39, 61–63, 81, 115–116
contrasts, space and 111–112
controller 43–44
Couthier, Loic 4, 8, 20, 23, 26, 41, 45, 54–55, 62, 68–69, 74, 120, 126, 130–133
creative choices 6, 6–7, 106
creative mixing 17–18, 62, 70, 84, 91
creativity 4, 5, 42
critical sounds 65–66, 76–78, 113
Cutting, Adele 5, 7, 10–11, 35, 42, 46–50, 78, 83

decay 108, 111
definition of done 28, **30**
delays 108–109, 114, *114*, 115
depth 112–113
design: accessibility and 134–135; of bus structure 58–59; collaboration and 45; in definition of done **30**; intentions 85; paper **122**, 132; readability and 67; requirements 99; side-chaining and 77; snapshot 71–72; of tools 23–24
design phase, high-level 52–53
dialogues 17, 40, 55–56, 89–91, 112, 118–119, 135, 140–141
disciplines, working with other 45
distance 38–39, 49, 64, 68, 79, 87, 110–111, 113, 141–142; *see also* space
distance attenuation 110
distance mixing 115
distant sounds 113, 141
ducking 78–79, 98

Index 147

Durity, Gordon 3, 12–13, 16–18, 27, 39–40, 63, 67, 119, 127
dynamic 92–99, 106–107, 127–128
dynamic EQ 60, 77
dynamic range *see* HDR Audio

early reflections 111–113
emotional attachment 12
emotional engagement 32, 102, 141
emotional feedback 14
enemy AI Foley 66
enemy AI weapons 66
enemy Foley 75, 140
energy, in lows 85–86
EQ cheat sheet 87
equalization: automation 44; baked *vs.* in-engine 98–99; device types and 132; mastering and 124, 128–129; tonal balance and 132
expectations, of progress 11–12, *12*
explosion 113
exterior acoustic 100–101, 141

feedback, from others 13–14
field of view (FOV) 118
flow state 4–6, *5*, 10
focal point 63–64, *64*
focus: communication and 63; efficiency and 34; end-points and 123–124; flow-state and 4–5, *5*; prioritization and 64; readability and 17; reflections and 112–113; side-chaining and 77; snapshots and 70–73; spectral balance and 82; tools and 24; transparency and 80; waterfall methodology and 29, 34
focus mix 136–137
Foley: background and 92; body 16; bus 51; enemy 75, 140; enemy AI 66; focal points and 49; footsteps 67; player 17, 23, 43–45, 52, *54*, 61, 66, 93, 140; reverb and 90, 101
footsteps 62, 67
frequency, source *vs.* in-engine 59–60
frequency extremities, space and 110–111
frequency spectrum 23, 29, **30**, 40, 49, 66, 77–78, 81–91, 110–111, 125, 128
functional phase **30–31**

gain 10, 41, 84, 93–95, 131
game accessibility *see* accessibility
game audio accessibility *see* accessibility
game audio engine 1, 16, 25, 40, 43, 48, 57–59, 75, 133, 140
game audio mixing *see* mixing
game developers 9–10, 27, 98, 121
game development 3, 11–12, 19–20, 23–26, 28, 46, 53, 93, 121, 139, 142
game direction 20, *20*
game engine 9, 17, 22–23, 40, 58, 82, 98, 142
game master **122**
game mastering 55, 83, 121, **122,** 132, 137
gameplay audio 66–67, 70–73, 76–77, *117*
gameplay engagement 1, 14, 32, 39, 42, 66, 81, 102, 141
gameplay feedback 62, 81, 87, 110, 114, 118–119
golden path 29, **30–31**
guidelines, from benchmark mix 22–23

hardware controller 43–44
HDR Audio 56–57, 64–65, 76–77, 83, 98, 137
headphones 14, 36, 55, 83–84, 96, 121–122, **123,** 130–131
hearing loss 135
hi-fi system 121
high-cut filter 59
high dynamic range audio 56–57, 64–65, 76–77, 83, 98, 137
high end, sharpness and precision in 87
high-pass filter 110
high-shelf filter 60, 77, 87, 110–111
high-SPL sounds 37, 101–102, 113–114, *114*

immersion 4, 7, 20, 65, 79, 115
impact 93–94
information clarity 97–98
interactive mixing 58, 106
interior acoustic 90, 100, 113
intrinsic space 102

Krekel, Rob 63, 72, 74, 78, 102, 110, 112, 135–136, 139–142
late reflections 113
level design **30,** 67
leveling 92–93
level of quality 28–29, **30–31**
LFE *see* low frequency effects (LFE)
light/sound speed difference 99
limiter 18, 126–127, 132, 142
limiting 124, 127–129
listener 39, 58, 62, 66–70, 98–99, 111–119
listening environments 38–39, 126, 128–129
listening positions 38–39
live mixing 29, 57–58, 97
LOQ 30
loudness 14, **30,** 41, 55, 57, 64, 76, 79, 81, 85, 96, 98–99, 104–105, 107, **122,** 123.124, 126–128, 138
loudness range **122**
loudness standards 126–127
low-cut filter 142
low end, scale and energy in 85–86, 99
low frequency effects (LFE) 86, 130–131
low-pass filter 110–111
L-states 28–29, **30–31**

macro mixing: agile methodology in 24–27; aspects of 25; effects calibration and 104; fader and 43; levels in 42; LOQ and **30**; micro *vs.* 25, 58; snapshots in 73
master bus 18, 127, 131–132
mastering 99; accessibility and 137; audio contents 22, 76, 92; compression and 124, 127–128; end-points and 123–124; equalization and 128–129; final 133; levels and 126–127; light touch in 142; limiting and 124, 127–128; listening environments and 126, 128–129; original intentions and 124; peaks and 126–127; plan 122–123, 132–133; second opinion in 125–126; sequential 121–122;

time for 121–123, *122*; volume and 125
Meyer, Brad 9, 13, 25, 32, 35, 41–42, 44, 52–53, 57–60, 71, 77, 80–81, 119, 124
micro mixing: creative mixing and 70; fader and 43; live mixing and 58; macro *vs.* 25, 58; snapshots and 73; volume and 42–43; waterfall methodology in 29–33, **30–31**
Minto, Ben 14, 19–20, 23, 36–37, 39, 74, 76, 82, 93, 96–99, 114, 124
mixing: basics 37–50; in context 39; linear/traditional *vs.* 1–2; live 57–58; over time 44–45, 106–108
mixing plan 11
mixing stage 7, 49, 88
mixing supervisor 27
mixing taskforce 34–35
mix supervisor 8
mix vision 11, 19–21, *20*, **30,** 63
mobile games 83–84, 126–127
modular structure 53–54, *54*
moment to moment 32–33, 45, 56, 58, 114
multi-band compression 122, 124, 127–128, 132
multi-step compression 95
Murch, Walter 17, 66–67
music 66
music composition 106
music design 25, 106

narrative audio 66–67, 69–73, 107–108, 113, *117*, 140–141
narrative immersion 4, 7, 20, 65, 79, 115
Nielsen, Tim 7, 10, 32, 34, 55–56, 62, 85–91, 93, 100, 111
noisiness 86, 87
non-critical sounds 65–66, 76–77, 113
normalization 57

object-based audio 120

panning 18, 29, 64, 67–68, 115–116, *117*, 117, 119, 136
panning rules 29, 136
parallel compression 93–94
parametric dynamic range 140

parent bus 51, 59, 93
pass-through 120, 131
PC games 37–39, 84
peaks 126–127
performance, mixing as 3–4
performance enhancement 3–4, 10, 13
perspective 12–14
planning, strategic 19–36, 88–89, 96, 106
playback devices 35–36, 83–84; *see also* speaker configuration
playback level 37–38
play by sound 67
player Foley 23, 43–45, 52, *54*, 61–62, 66, 93, 140
player weapons 66
point of interest 64, 112, 115
positioning settings 115
positions, listening 38–39
post-effects 102–103
practice 8–9
pre-delay 114, *114*
predictability 1–2
pre-dubs 4, 25, 89
pre-effects 102–103
pre-mixing 25–26, 29, 39, 43, 55, 57–58, 89
preproduction *122*
productivity 4, *5*
progress, expectations of 11–12, *12*
props sounds 116
prototype *33*, 38, 134
prototyping phase **30–31**
proximity 87
psychology, mixing 3–18

readability 2, 17, 64, 117–120, 130–131, 139–140
references, in planning 19–20
reflections 112–113
responsibility definitions 28–29
reverbs 90, 103–104, 108–109, 111–113, 115, 141–142
reverb tail 141
richness 86
role definitions 28–29
rule of 2.5 17, 66–69
rules: from benchmark mix 22–23; breaking of 14–15

scale, in lows 85–86, *87*
screen size 38
self-confidence 10
self-questioning 71
sense of depth 113, 120, 131
shape, spatial 102
shared ownership 96–97
sharpness 87, *87*
side-chain 49, 77–78, 98, 130, 140–141
snapshots 70–73
sonic spaces 120, 131
soundbar **123**
sound design 39, 44, 89, 137
sound effects 1, 6, 17, 87, 89, 93, 107, 109, 118
sound families 115–117, *117*
sound prioritization *see* audio prioritization
sound sources 84, 101, 103, 110–111, 113, *114*, 115–116
sound speed 99, *114*
sound travel 114
source contents 40–41
space: acoustic 108–109; context and 115–116; contrasts and 111–112; depth and 112–113; dialogues and 112; frequency extremities and 110–111; high-SPL sounds and 113; positioning settings and 115; reflections and 112–113; reverb and 112–113; sound families in 115–117, *117*; speaker configuration and 117–120; visual cues and 114, *114*
spatial shape 102
speaker configuration 90–91, 117–120, 130–131; *see also* playback devices
spectral balance 111
spectral balance adjustment 82–83
speech 48
sprints 25–26
stereo output 48, 55–56, 83, 91, 121, 130–131
stories, user 26
strategic immersion 115
strategic planning 19–36
sub buses 51–53, 55, 59, 79
subtractive equalization 84–85, 138

subtractive mixing 138
surround mixing 18, 55, 62, 69, 83,
　90–91, 111, 113, 117, 119, 121,
　123, **123,** 130, 1222

tactical immersion 20
tactical information 102, 141
target audience 13, 19, *20*, 36, 83, 125
taskforce, mixing 34–35
timbre 16
time, mixing over 44–45, 106–108
time management 46–47
timing, of mixing 16
tonal balance 132
tonal compression 94–95
tonality 132
tonal shape 85, 128–129
tools: design of 23–24; overreliance on 9; vision and 23–24
top-down approach 51–53, *52*
transitions 79–80

user stories 26

vertical slice 32, *33*
vision 4, 20, *20*, 23–24, **30,** 34, 42, 63, 119, 136, 138
visual cue 66, 81, 99, 114, *114*, 116, 136
voice 77, 90
voice culling *74*
voice design 25
voice management 49, 65, 78
volume 37–38; automations 44; gradual increase in 43; importance of 41–43; leveling *vs.* compression in control of 92–93; mastering and 125; micro mixing and 42–43; of reverbs 104–105; targeted playback 23

waterfall methodology 16, 29–33, **30–31,** *33*, 34, **123**
wetness 111, 115–116, *117*, 117
world-building audio 6, 62, 65–68, 75, 113, 115, *117*, 120, 138